LONDON
THROUGH TIME
Michael Foley

To Pat, Helen, Dot and Mary

First published 2010

Amberley Publishing
Cirencester Road, Chalford,
Stroud, Gloucestershire GL6 8PE

www.amberley-books.com

Copyright © Michael Foley, 2010

The right of Michael Foley to be identified as the
Author of this work has been asserted in accordance
with the Copyrights, Designs and Patents Act 1988.

ISBN 978-1-84868-893-3

British Library Cataloguing in Publication Data.
A catalogue record for this book is available from
the British Library.

Typeset in 9.5pt on 12pt Celeste.
Typesetting by Amberley Publishing.
Printed in the UK.

Introduction

The basis of this book is a series of old images of London taken ninety to a hundred years ago. Alongside each image is a modern photograph of the same place or item today. You will see that there are a number of obvious differences. One is the enormous buildings that now dominate the skyline of London. The move from horse-drawn to motorised transport is another, along with the enormous increase in the volume of traffic. On an individual basis, there is also the change in fashion of the clothes that people in the photographs are wearing.

There are also some more unexpected differences that became obvious as I began to compare the old images with the modern photographs. Where there were once clear views of the buildings lining many of London's streets, in many cases these are now almost completely obscured by trees. In a number of the old images there are no trees in the streets at all. In the old image of Kingsway there are some recently planted trees that have now grown to block the same view.

Another difference that also stood out as I researched this book was the presence of the military on London's streets. This may not seem unusual, especially in the area around Buckingham Palace and Horse Guards Parade. Today there is an obvious ceremonial aspect to the military, but in a number of the old images the forces on the streets were there for a far more serious reason. Many were on their way to fight in Europe during the First World War. A number of the forces were not English at all, but men from the colonies or allies come to help out Britain in our time of need. Many of these men then returned to take part in the ceremonies that were held on London's streets to celebrate victory.

Another clear change is in relation to the Thames. The old images show a river crowded with ships and boats of all kinds from the days when the Thames was London's trading lifeline. The river was the employer of huge numbers of people. Now the few boats using the river are mainly pleasure craft.

Despite showing some of what has changed in London in the age of photography, *London Through Time* is as much about how little the city has changed. The past hundred years or so have had no effect on places such as the Tower of London, the old houses on Fleet Street, and the Old Curiosity Shop on Portsmouth Street. Even the Great Fire of London failed to raze these particular buildings.

Whatever interests you most about London, whether it is what has changed or what has not, I hope that you will find something to divert you in this book.

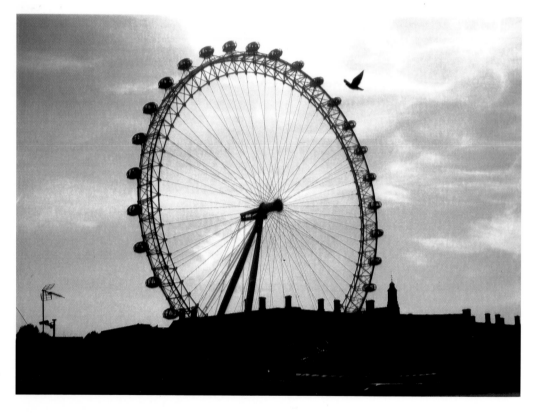

The London Eye, or Millennium Wheel, is 135 feet high. It is the tallest Ferris wheel in Europe and was the tallest in the world when it was built. It has become the most popular paid-for tourist attraction in the UK – understandable considering the magnificent views.

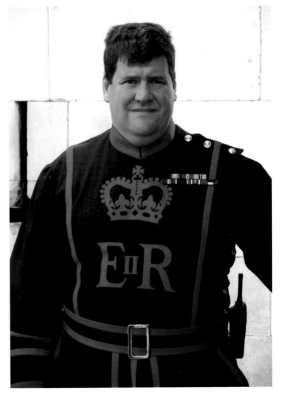

Beefeaters

Although known as Beefeaters, the correct name for the wardens of the Tower of London is Yeoman Warders. Traditionally they are employed to protect the crown jewels. Since security is now carried out by others, the Beefeaters have become tour guides. They have themselves become part of the the Tower's attraction.

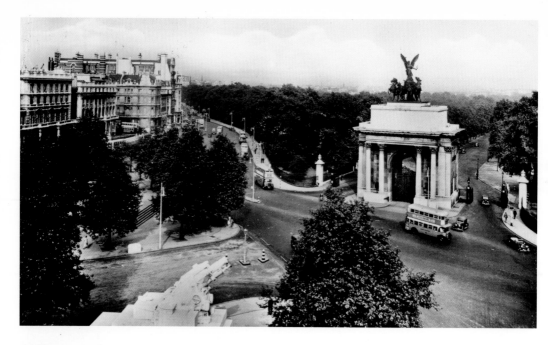

Wellington Arch

A triumphal arch constructed to commemorate victory in the Napoleonic Wars, Wellington Arch was designed as a grand entrance to London from the west. Nearby Apsley House, the home of the Duke of Wellington, was known as 'Number One, London'. The arch now stands on a traffic island, which hosts a number of other military memorials.

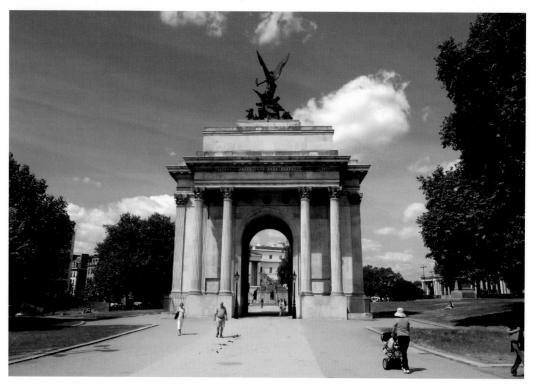

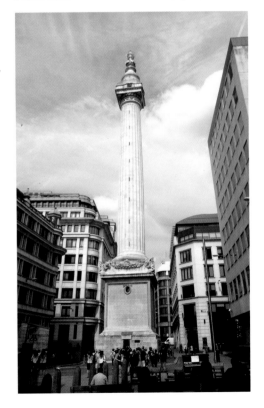

The Monument

Built to commemorate the Great Fire Of London of 1666, the Monument was designed by Christopher Wren. Reflecting the views of the time, it originally had a plaque denouncing the fire as a Roman Catholic plot. It is open to the public, and if you can survive the 311 stairs to the top, it offers a panoramic view of the surrounding area. The modern photograph is taken from Pudding Lane, where the fire began.

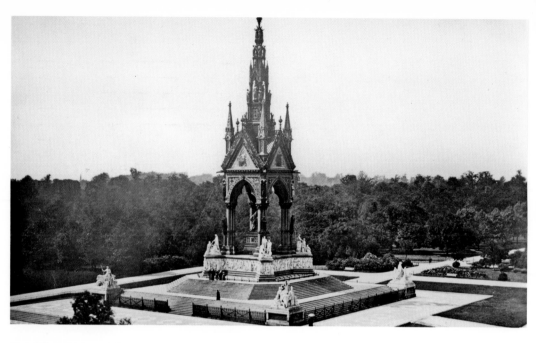

The Albert Memorial

This George Gilbert Scott-designed memorial is dedicated to Prince Albert, the husband of Queen Victoria, who died of typhoid in 1861. The memorial stands in Kensington Gardens opposite the Albert Hall. It opened in 1872 and cost £120,000 to build.

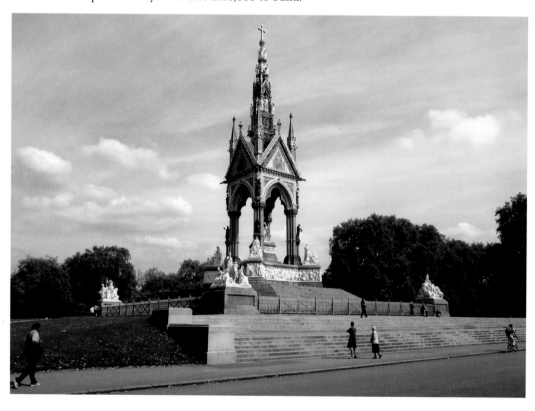

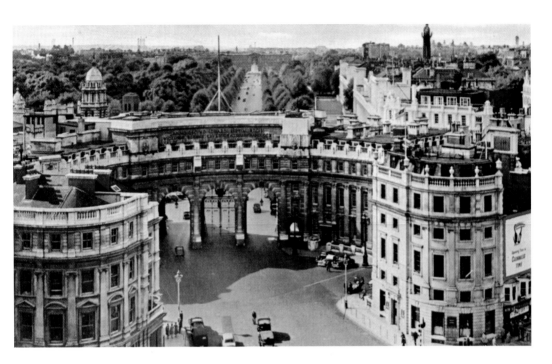

Admiralty Arch

Standing in the corner of Trafalgar Square, Admiralty Arch forms part of the ceremonial route from Buckingham Palace to the House of Commons. It was commissioned by Edward VII as a memorial to his mother, Queen Victoria. The arch is now used by the British Government.

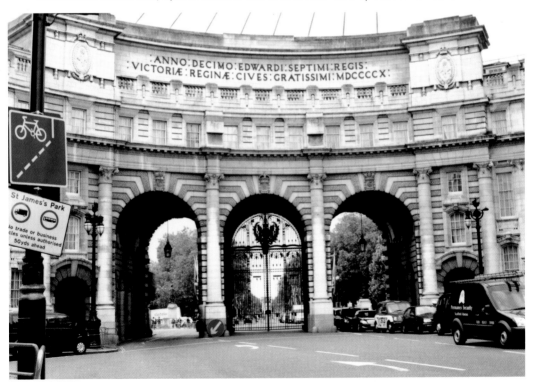

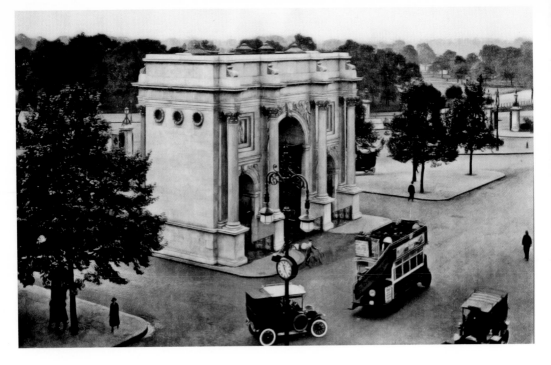

Marble Arch

Like Wellington Arch, this is another triumphal arch based on those built in ancient Rome. It was erected in 1828 on the Mall as an entrance to Buckingham Palace. It was moved to its present position in 1851. While it was being used as a police station, one of the officers based here was Samuel Parkes, who had previously won a Victoria Cross for his part in the Charge of the Light Brigade in 1854. Little about the arch has changed – apart from the volume of traffic passing it.

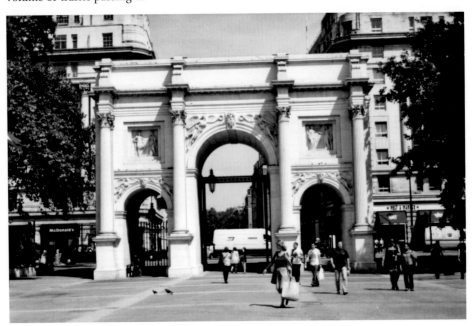

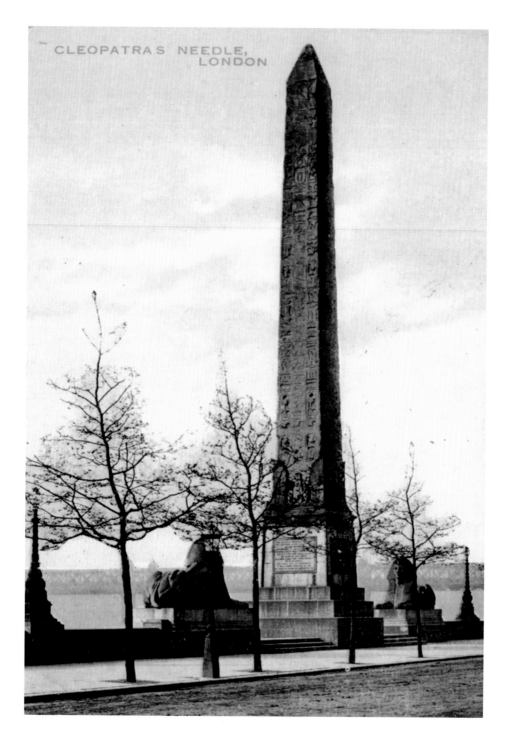

CLEOPATRA'S NEEDLE,
LONDON

Cleopatra's Needle
This ancient Egyptian obelisk has nothing at all to do with Cleopatra. In 1819 it was presented to Britain by Muhammad Ali, the ruler of Egypt, to commemorate Nelson's victory in the Battle of the Nile. It is one of a pair – the other is in New York. The needle stands on Victoria Embankment and is flanked by two faux-Egyptian sphinxes.

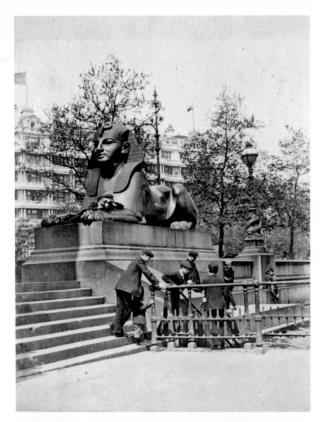

Sphinx (I)
This early image shows a group of people obviously interested in the steps leading down to the Thames from the sphinx on the eastern side of Cleopatra's Needle. Little has changed today, except that the steps leading to the river are now enclosed.

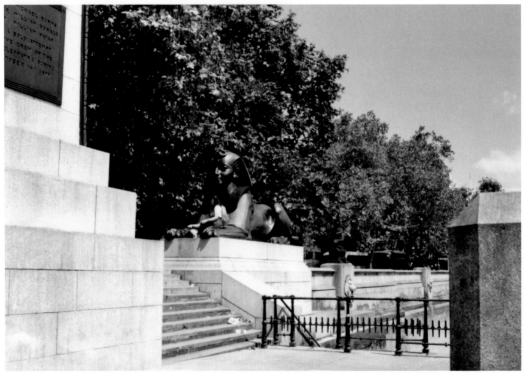

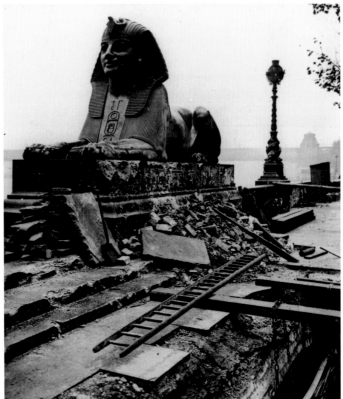

Sphinx (II)
The hole in the pavement by the side of the sphinx in the old image was caused by an air raid in September 1917. The bomb caused damage to the pavement and the sphinx. The modern photograph shows a small plaque at the far end of the base of the statue explaining the damage.

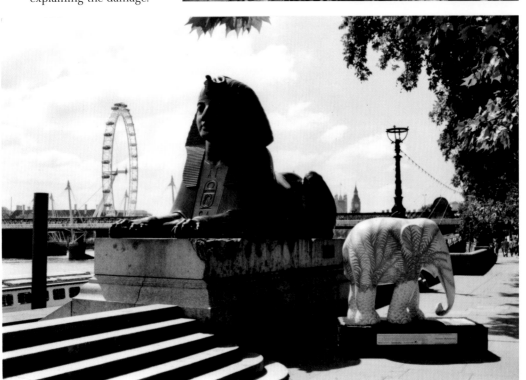

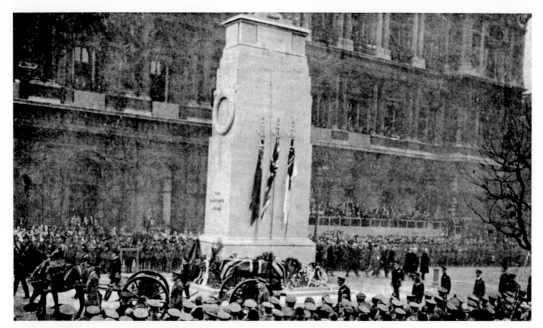

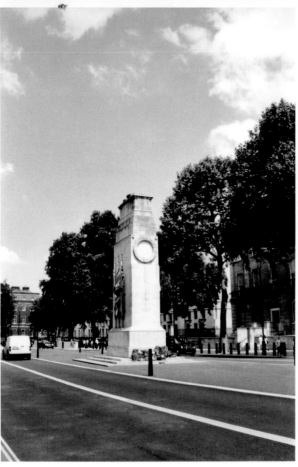

The Cenotaph

Erected in 1919 after the end of the First World War, the Cenotaph was originally made of wood. It was replaced with the present memorial in 1920 and since then it has been the site of London's Remembrance Day ceremony. The old image shows the funeral of the unknown warrior – an unidentified soldier from the battlefields of the war who was buried in Westminster Abbey.

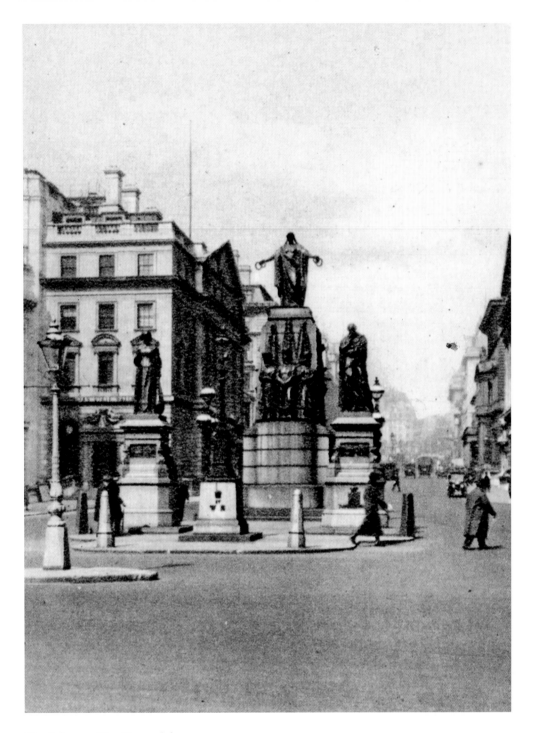

The Crimean War Memorial
One of numerous military memorials in London, the Crimean War Memorial – three guardsmen and a female figure signifying honour – stands in Waterloo Place. It was made from the Russian cannons captured during the Siege of Sevastopol and was unveiled in 1861.

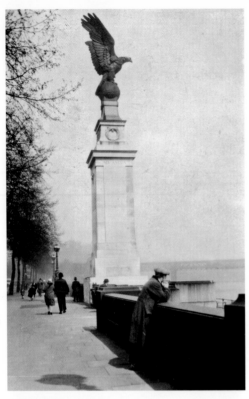

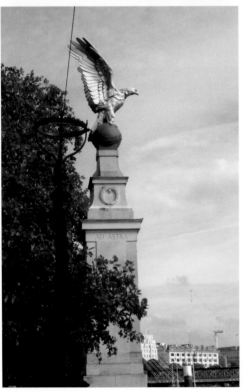

The Royal Air Force Memorial
Standing on the east of the the Ministry of Defence building on Victoria Embankment, the RAF Memorial looks across to the London Eye. It was erected in 1923 to commemorate those members of the RAF who died in the First World War. A further dedication to those who died in the Second World War was added later. In 2005 a memorial to the Battle of Britain was placed nearby.

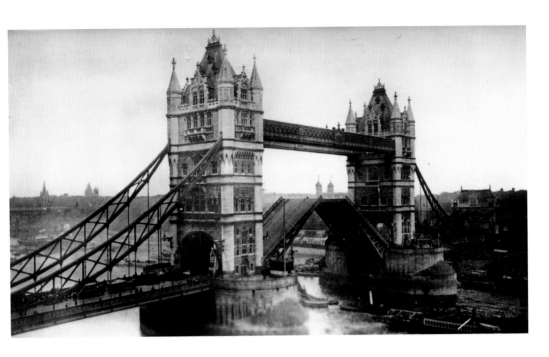

Tower Bridge

The site was chosen because of the rapid development of the East End in the late nineteenth century. A fixed bridge would have denied particularly large ships entry to the Pool of London, so the design was chosen from a competition that had only one stipulation: the bridge had to capable of being raised. This is done much less frequently now, as large ships rarely come this far.

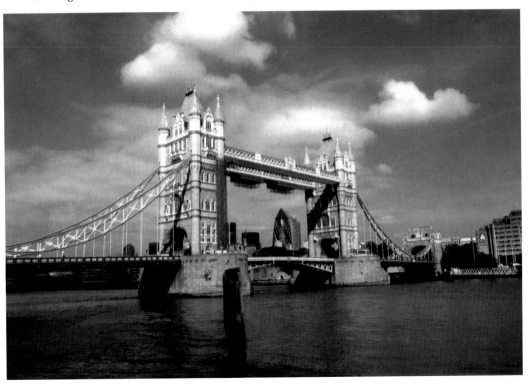

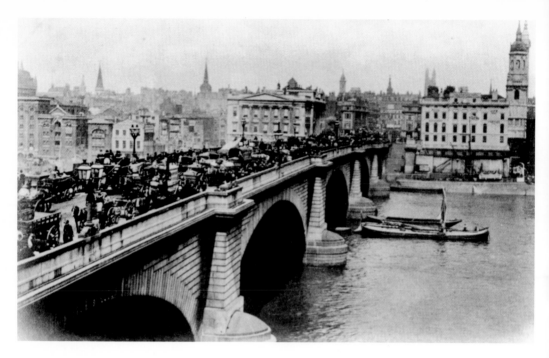

London Bridge

The first bridge to cross the Thames in London was built on this site, which marks the Pool of London's western limit. There have been a series of bridges here, including a medieval bridge that had houses, shops, and a chapel built along either side. The present bridge was completed in 1973 and includes wide pavements as well as a very busy road.

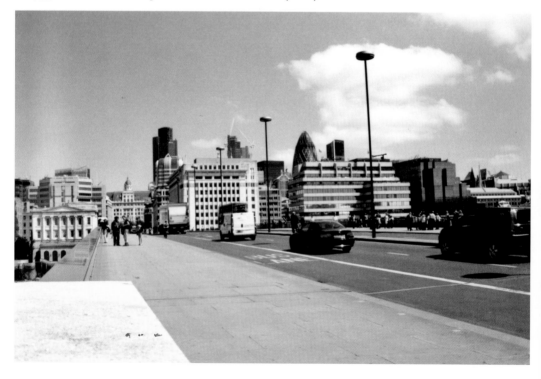

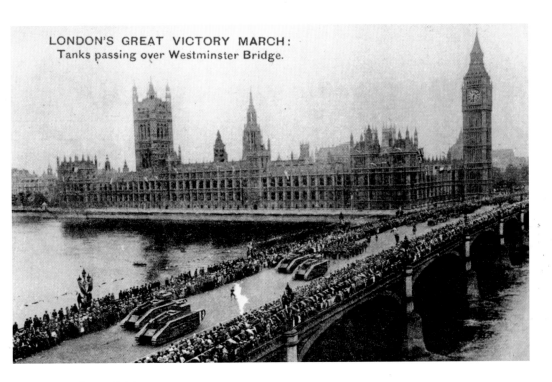

LONDON'S GREAT VICTORY MARCH:
Tanks passing over Westminster Bridge.

Westminster Bridge

The Great War is over and London celebrates with a victory march across Westminster Bridge. The new weapon, the tank, which terrified the enemy when it was first used, is visible crossing the bridge and travelling toward Parliament. The view as one crosses it has changed little.

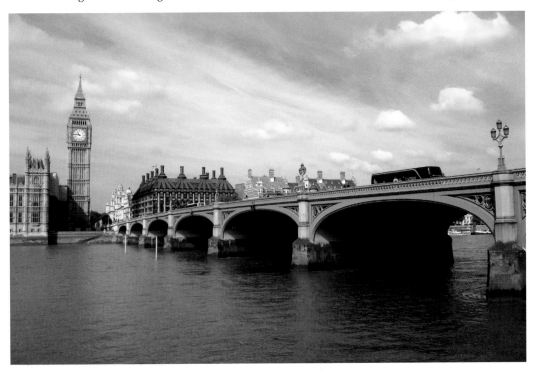

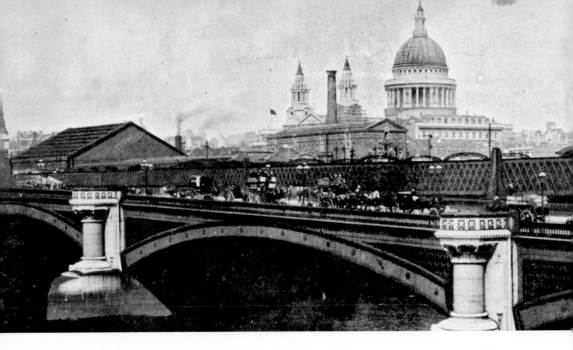

Blackfriars Bridge

The first bridge on this site opened in 1769. It was the third bridge across the Thames in London and was called the William Pitt Bridge. It was made of stone but by the mid-nineteenth century it needed serious repairs. The present bridge was therefore built to replace it in 1869.

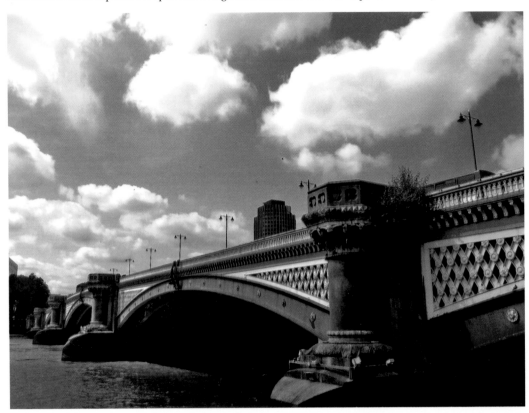

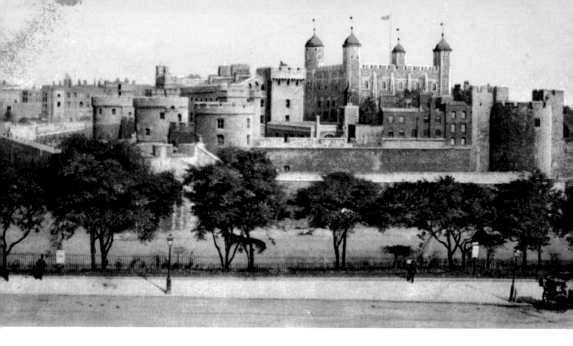

The Tower of London

Founded by William the Conqueror in the eleventh century, Her Majesty's Royal Palace and Fortress has been used as for defence, as a palace, and as a prison throughout history. It is now open to the public and contains several collections, including the Crown Jewels. It no longer dominates the skyline as it did in the past.

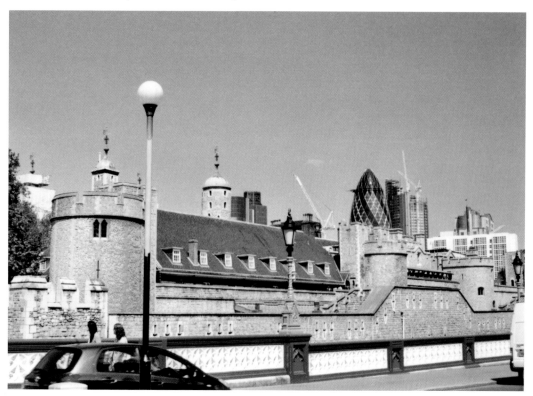

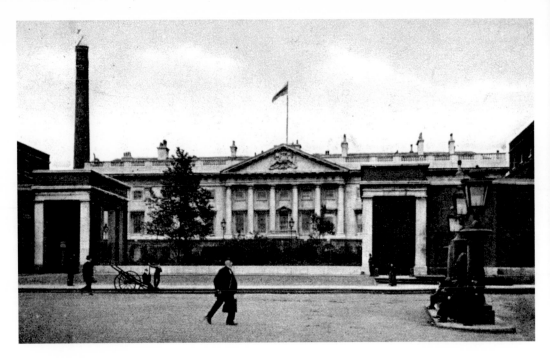

The Royal Mint

English and British coins were made in the Tower of London until the end of the eighteenth century, when the machinery used became outdated. The Royal Mint was built nearby and began production in 1810, when it used steam power. The mint at Tower Hill was used until 1968, when it was moved to Wales. The building is now in private use and trees have been planted along the front, obscuring the old view.

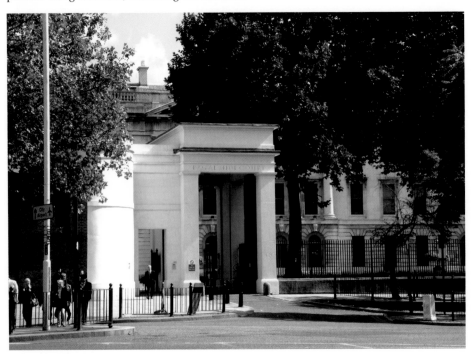

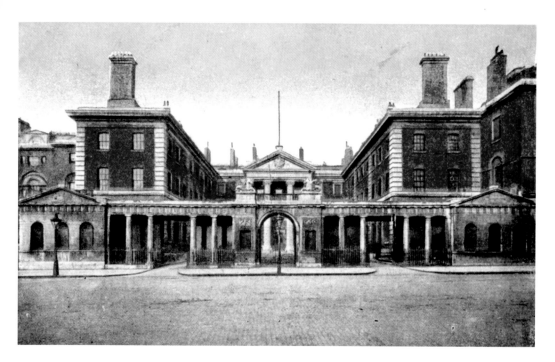

The Old Admiralty Building

Backing on to Horse Guards Parade is the Old Admiralty Building. It was originally built in 1726 but was much expanded in the nineteenth century. The Navy later became part of the War Office. The building is now used by the Foreign and Commonwealth Office. The modern view shows the building from Horse Guards Parade.

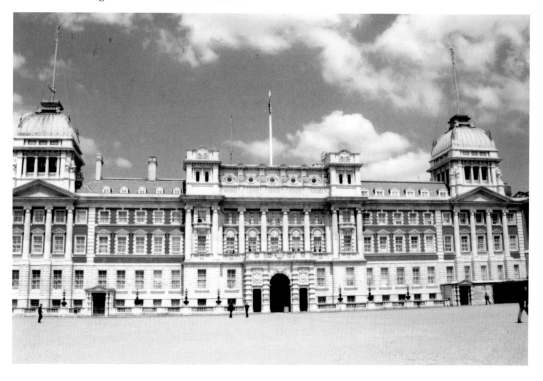

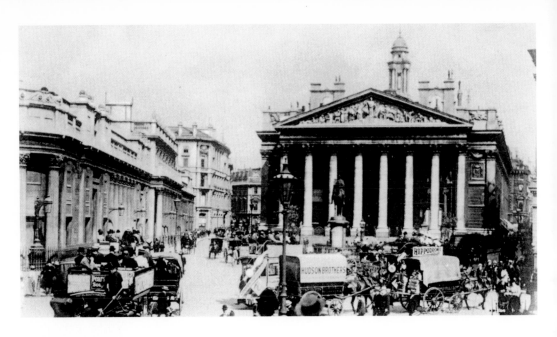

The Royal Exchange

Although this site was London's official centre of commerce from the reign of Elizabeth I until the twentieth century, the present building is actually the third to be built on the site. It was opened in 1844; the previous two were destroyed by fire. It ceased to operate as a trading hub in 1939 – it is now a shopping centre.

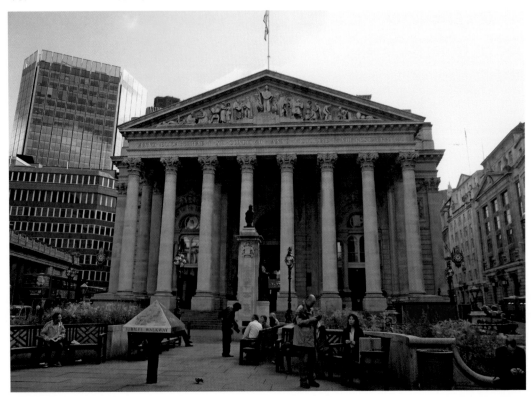

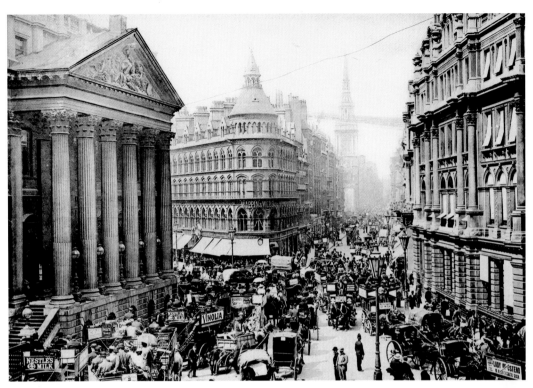

Mansion House

Early Lord Mayors of the City of London usually worked from the headquarters of whichever guild they represented. After the Great Fire of 1666, the idea of creating a permanent home for the Lord Mayor's duties was put forward, but the Mansion House was not completed until 1759. The house today holds a number of historic collections, including a fine selection of seventeenth-century Dutch and Flemish paintings.

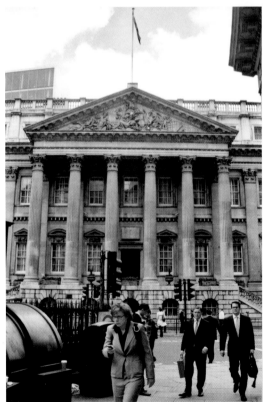

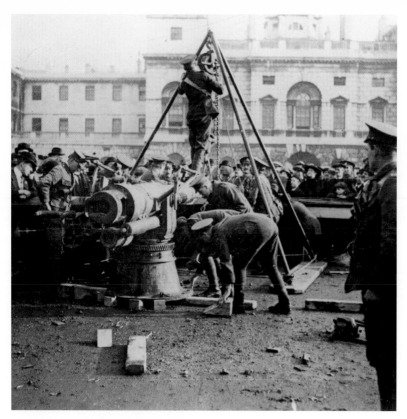

Horse Guards (I)
It was common practice to exhibit captured enemy weapons during the First World War. This is a naval gun from the SMS *Emden* being set up at Horse Guards. Today, Horse Guards is popular with tourists for ceremonial events such as the changing of the guard. At these times large stands full of seating are erected around the area.

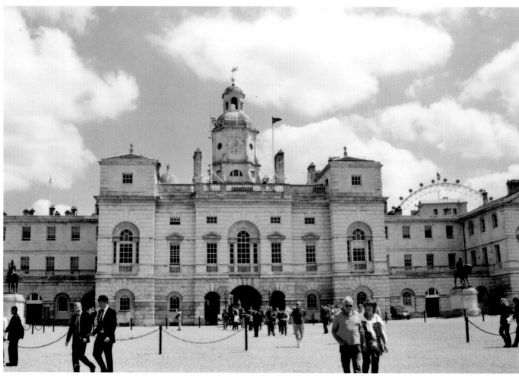

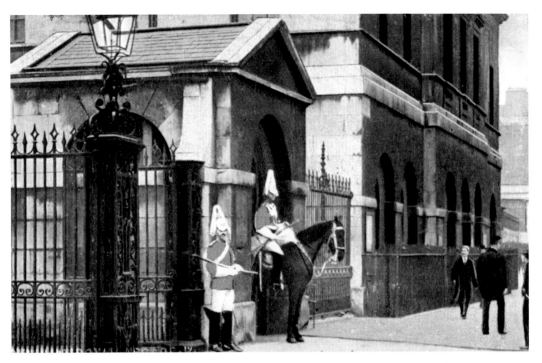

Horse Guards (II)

The front of the Horse Guards building in Whitehall is well known for the guards dressed in their fine uniforms. The old image suggests that the presence of the guards aroused little interest. That is no longer the case; the guards are now a great tourist attraction. The notice on the wall is a sign of present-day worries about health and safety.

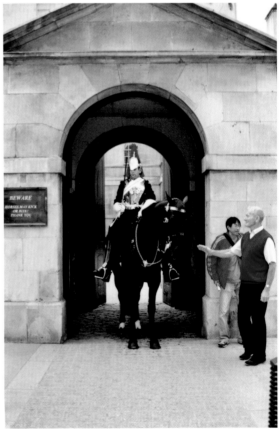

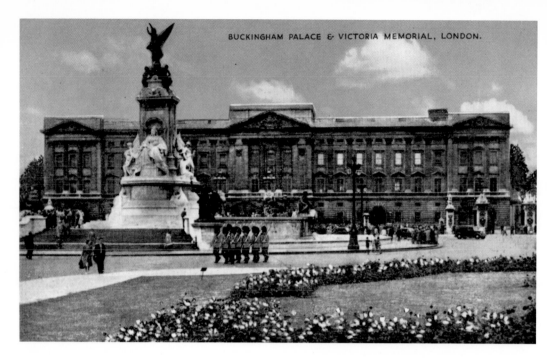

BUCKINGHAM PALACE & VICTORIA MEMORIAL, LONDON.

Buckingham Palace

Long known as Buckingham House, the palace belonged to the Duke of Buckingham until it was bought by George III in 1761 as a residence for Queen Charlotte. It became known as the Queen's House until the nineteenth century. It became the official royal residence when Queen Victoria came to the throne in 1837. Since the end of the nineteenth century, little has changed about the building. It is now a popular site for tourism, with regular displays of military bands.

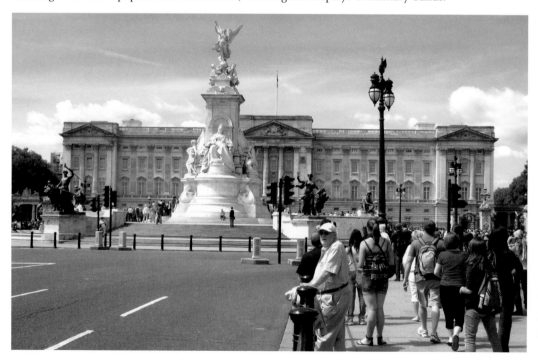

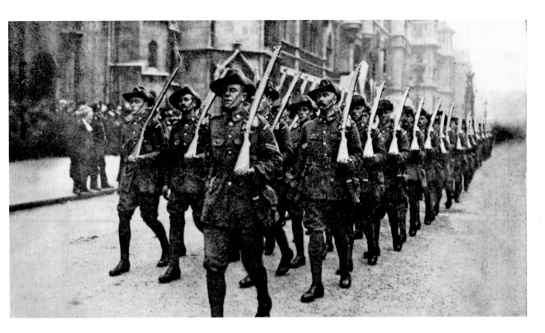

The Law Courts

The George Street-designed Royal Courts of Justice in the Strand were opened by Queen Victoria in 1882. The building is surrounded by four Inns of Court. In the old image, New Zealand troops march past the building during the First World War.

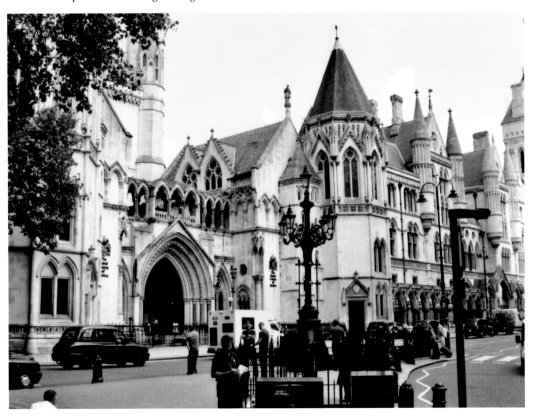

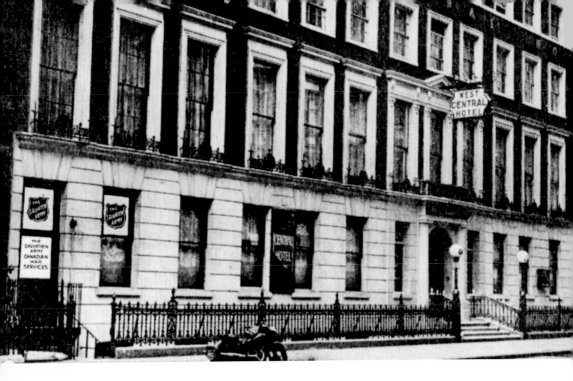

Southampton Row
Above, a Salvation Army Hotel used by Canadian soldiers in the First World War. It no longer exists. Formerly Kingsgate Street, Southampton Row runs from Russell Square to Holborn.

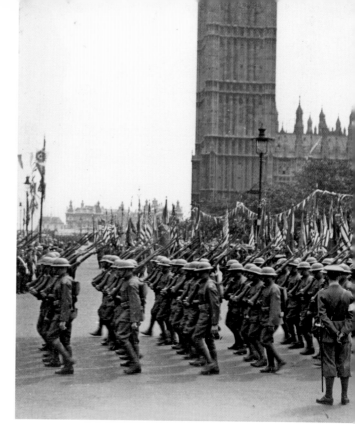

The Houses of Parliament
The old image shows the arrival of our American allies during the First World War. These US troops marching past the Palace of Westminster are no doubt on their way to France. Below is a view from the south bank of the Thames.

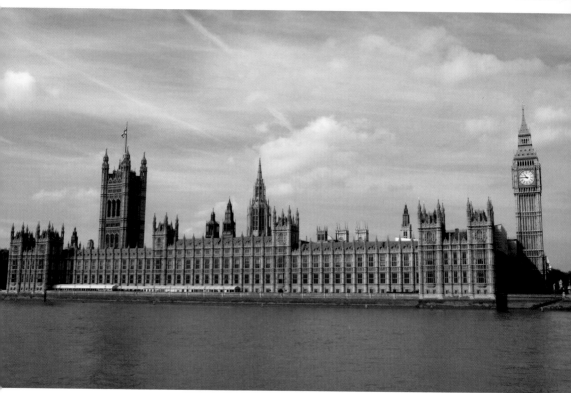

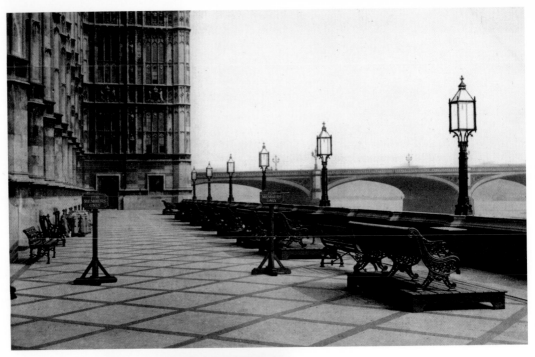

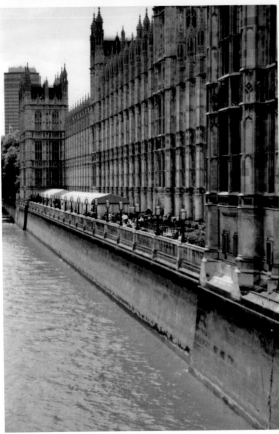

The Terrace, Parliament
The terrace was once used for a pleasant stroll in the fresh air. It seems to be much more crowded today, perhaps thanks to the popular restaurant.

Lambeth Palace

The London residence of the Archbishop of Canterbury dates back to the thirteenth century and stands on the south bank of the Thames, upstream from the Houses of Parliament. It has been the scene of violence in the past and was attacked during the Peasants' Revolt of 1381. It was sacked by Cromwell's troops during the English Civil War and was also used as a prison for a time.

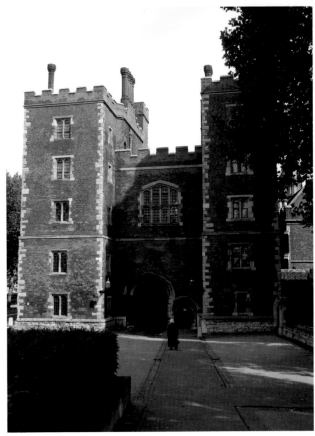

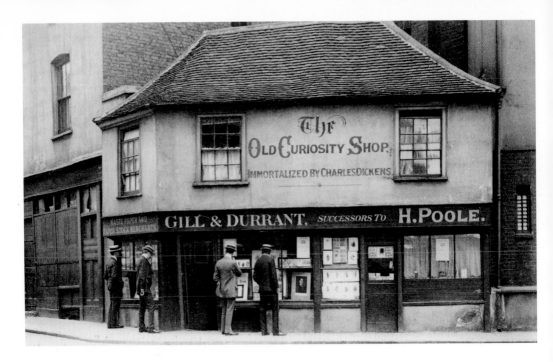

The Old Curiosity Shop

Dickens aside, this building has a great history of its own. It dates back to the sixteenth century and claims to be the oldest shop in Central London. It was built from the timber of old ships and managed to survive the Great Fire of 1666. There is no proof that the shop was the inspiration for Dickens' book of the same name – the name followed the success of the novel – but he did live in the area for some time and may have known it.

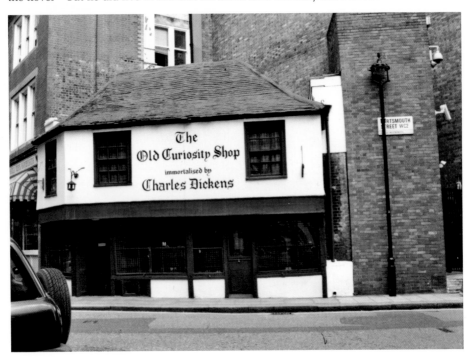

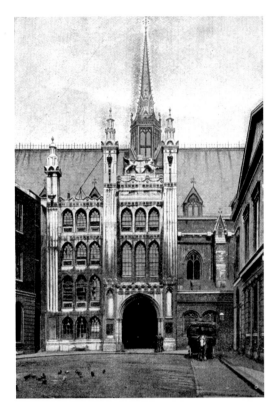

The Guildhall

Since the twelfth century, the Guildhall has been the City of London's administrative centre. The Lord Mayor has often been in dispute with the Crown over who controlled the City; he was even occasionally instrumental in persuading the population to oppose royalty and even to support rebellions. Today the building is used for exhibitions and for civic functions.

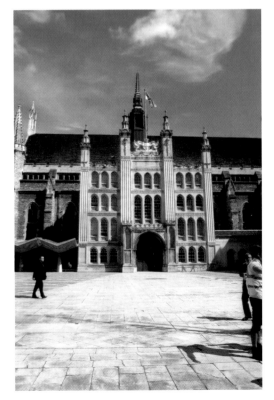

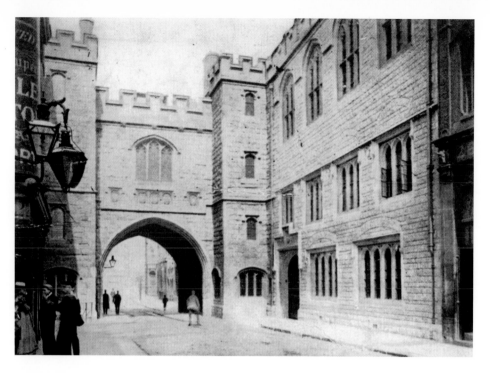

St John's Gate

This is all that is left of the entrance to the Priory of the Knights of St John – the Knights Hospitallers. Much of what remains is a Victorian restoration. It has been used for a number of different occupations over the years, but is now the entrance to the museum of the St John Ambulance, a charity that evolved from the Knights Hospitallers.

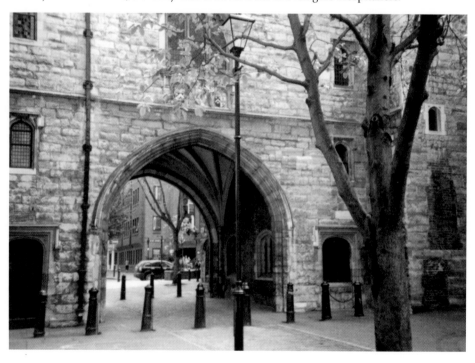

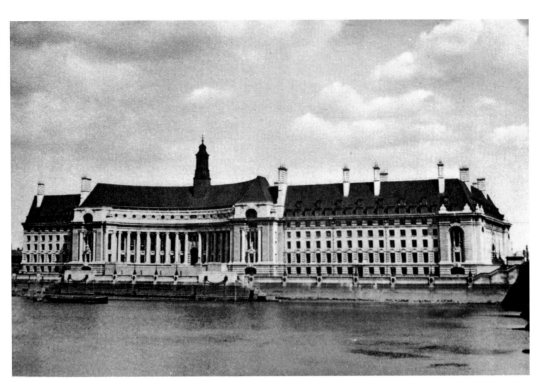

County Hall
The building of County Hall began in 1911 and during its construction the remains of a Roman ship were discovered. It became known as the County Hall Ship. The building opened in 1922 and was the home of the Greater London Council until it was abolished in 1986. The building now houses the London Aquarium, the London Film Museum, several art exhibitions, two hotels, restaurants, and flats.

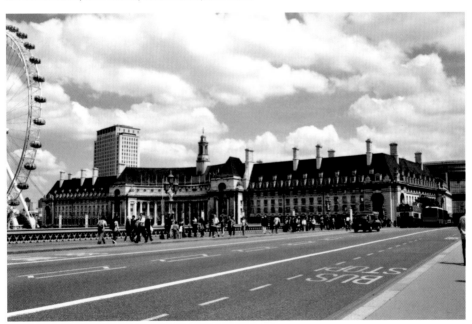

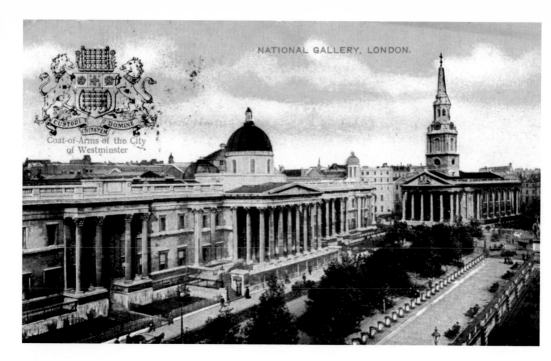

Coat-of-Arms of the City of Westminster

The National Gallery

In 1824, Parliament agreed to pay £58,000 for the art collection of the banker John Angerstein. This was to be the basis of a national collection of art. The paintings remained on display in Angerstein's house at 100 Pall Mall until the National Gallery was built in 1838. The gallery now houses one of the greatest collections of European art in the world.

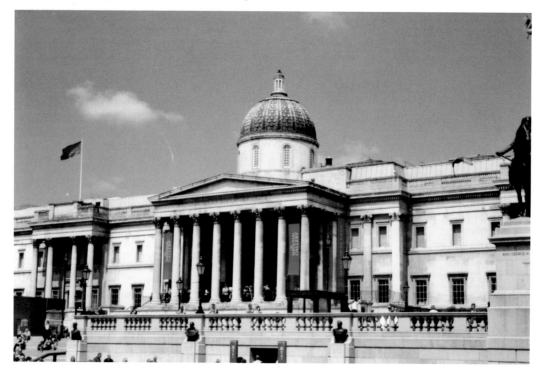

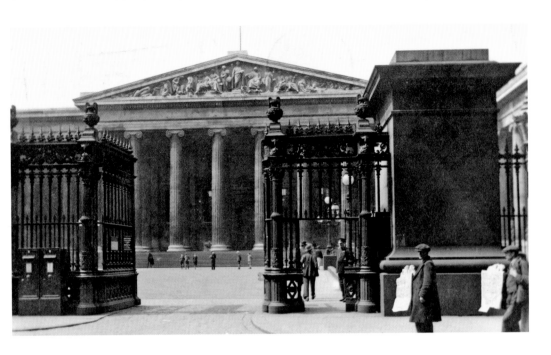

The British Museum

The origins of the British Museum lie in the private collection of Sir Hans Sloan. His collection was put on public display in 1759 at Montague House, which stood on the site of the present building. The collection grew in line with British expansion of its colonies, as items were brought back from around the world.

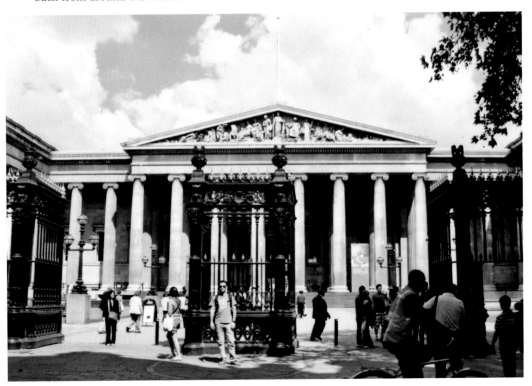

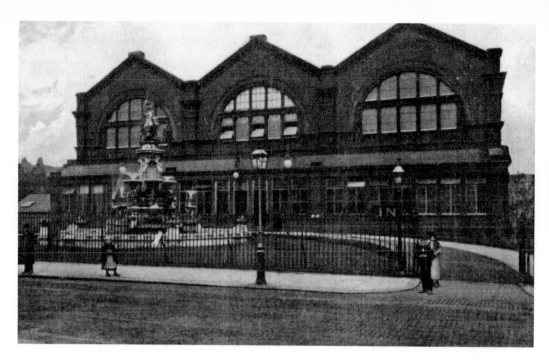

The V&A Museum of Childhood

The Bethnal Green Museum opened in 1872 as a satellite of the South Kensington Museum, now the Victoria and Albert Museum. It held many of the exhibits left behind by the temporary Crystal Palace Exhibition of 1851. In the 1920s, curator Arthur Sabin began to focus on childhood and in 1974 it became the V&A Museum of Childhood.

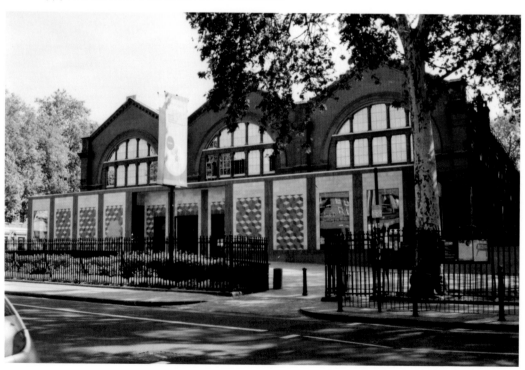

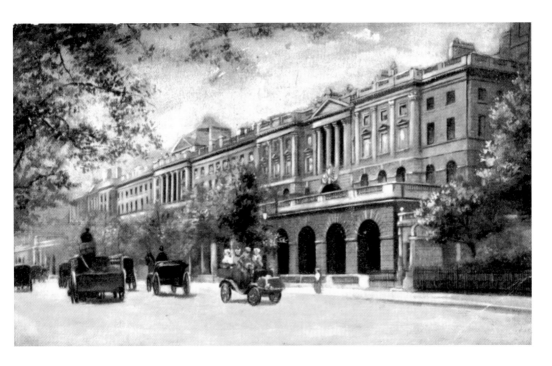

Somerset House

This building took its name from its original owner, the Duke of Somerset, who commissioned it in the sixteenth century. He was then executed and the house was seized by the Crown. It became a royal residence and was used as an army headquarters during the Civil War. It was demolished and rebuilt in the eighteenth century and used as public offices. Since HM Revenue & Customs moved out in 2009, it has been largely used to hold exhibitions.

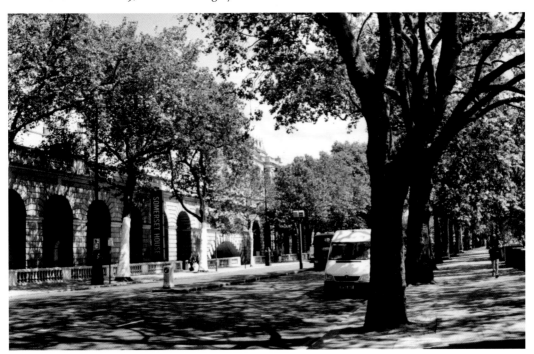

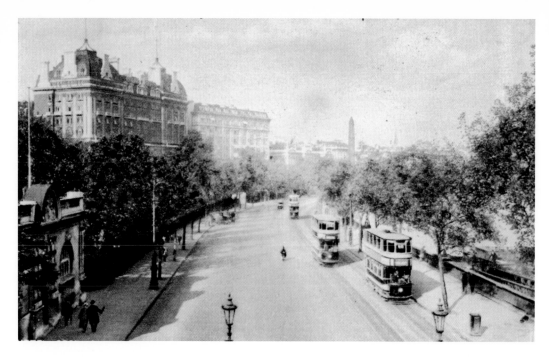

Victoria Embankment (I)

The Hotel Cecil (above) was once the largest hotel in Europe and during the First World War it became a recruiting office for one of the Sportsmen's Battalions, which were made up of sports celebrities and public school boys. Today you are more likely to see joggers than soldiers on this the busy tree-lined road.

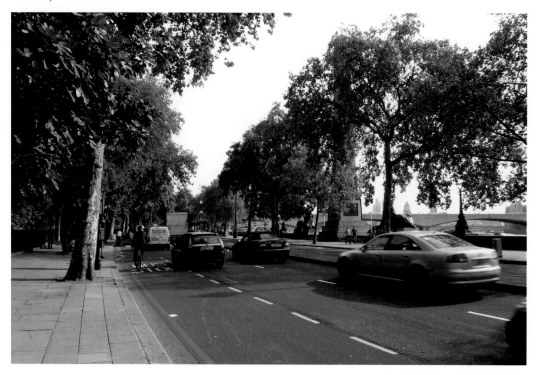

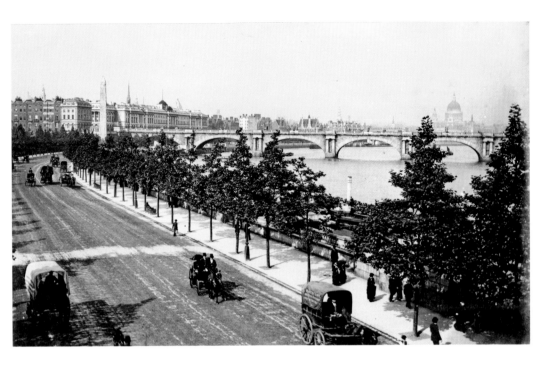

Victoria Embankment (II)

The old image of the embankment shows the types of transport that frequented London's roads in the past. It also shows a skyline dominated by St Paul's Cathedral. The modern photograph shows a similar view of the river, here crossed by Waterloo Bridge, but St Paul's is no longer the only high building on the skyline.

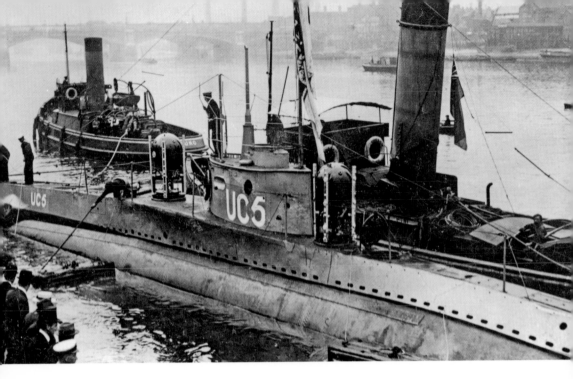

The Thames

Captured enemy weapons were displayed on the Thames during the First World War. This German U-boat was one of the spoils shown to the public. There is another warship on the river from the Second World War, but this one is British. HMS *Belfast* is now a floating museum.

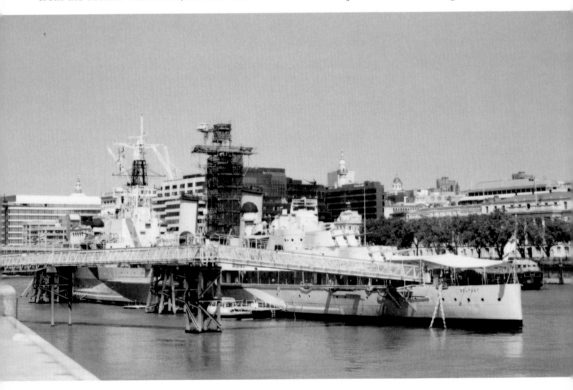

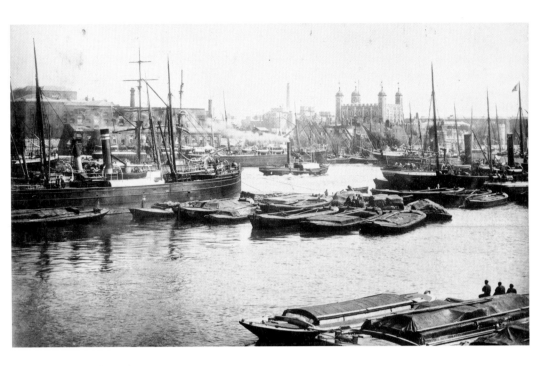

The Pool of London

This view of the stretch of river between Tower Bridge and London Bridge is from when the Thames was still a vital trading link with the rest of the world. The river was full of large ships and barges. A modern view of the same area shows the decline in river-borne trade. The Thames is now empty, giving a clear view of the Tower of London.

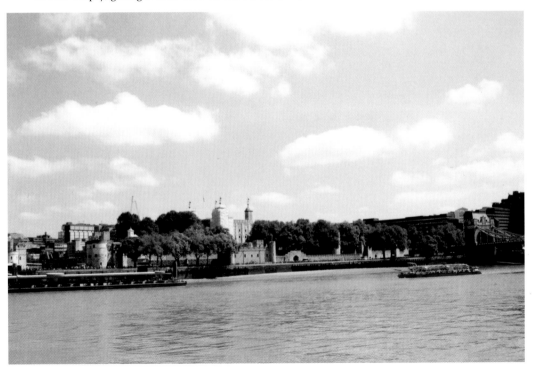

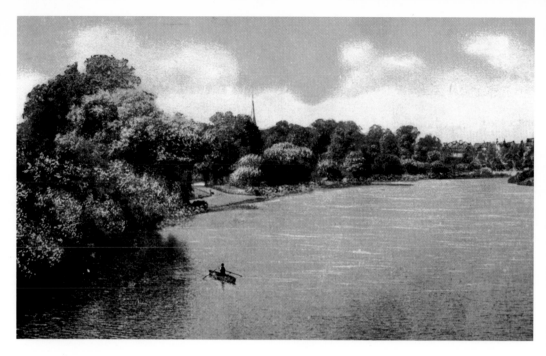

The Serpentine

The lake known as the Serpentine is situated in Hyde Park. The bridge across the lake marks the boundary between Hyde Park to the east and Kensington Gardens to the west – where the lake is known as the Long Water. Little has changed between these photographs; however, the bridge is much busier – it now carries constant traffic.

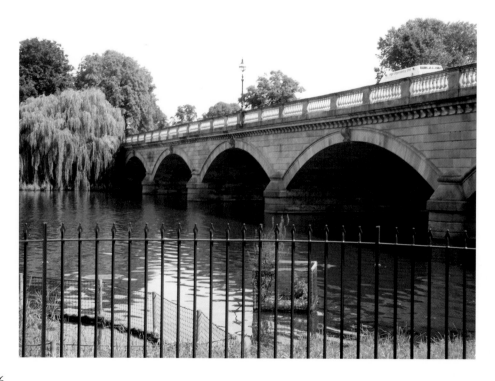

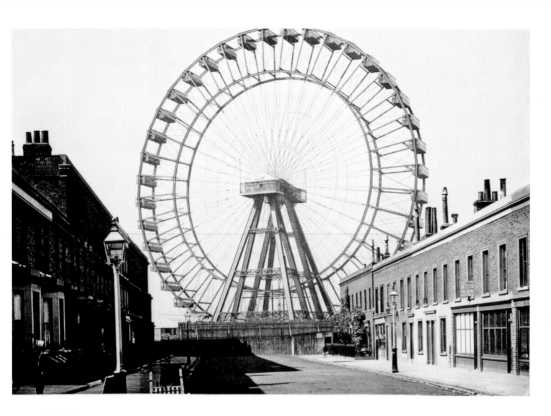

Earls Court

This area has long been famous for exhibitions and shows, including Buffalo Bill's Wild West Show in the late 1880s. The great observation wheel above was photographed during an 1890 exhibition. Today's art deco exhibition centre was built in the 1930s and is used to host exhibitions and concerts.

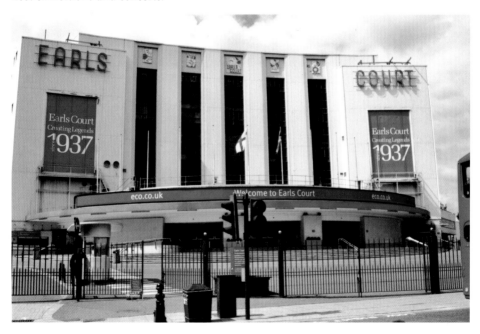

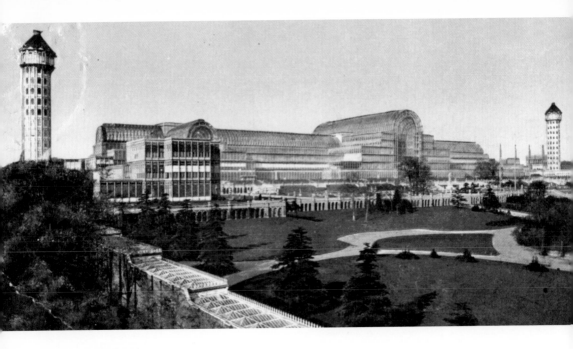

The Great Exhibition

The Crystal Palace Exhibition was held in Hyde Park in 1851. It was the idea of Queen Victoria's husband, Prince Albert. The exhibition was a way of displaying the triumph of Britain's success in the Industrial Revolution. The enormous glass building, the Crystal Palace, was built especially for the exhibition in Hyde Park, between the road and Rotten Row. The structure was relocated and the site is now parkland, with the Albert Memorial in the distance.

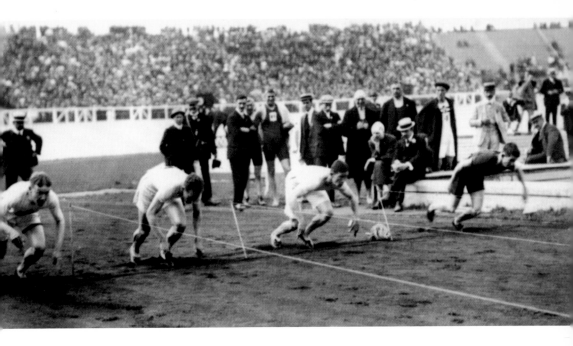

White City

This area in West London was used to hold the Franco-British Exhibition in 1908, which was supposed to demonstrate the improved relationship between the two countries. White City Stadium was also built at the same time and was used to stage the 1908 Olympic Games, above. The stadium was later used for greyhound racing but was demolished in 1985; the BBC built its large radio complex on the site.

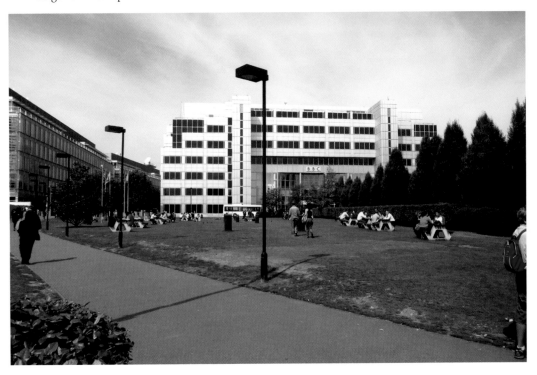

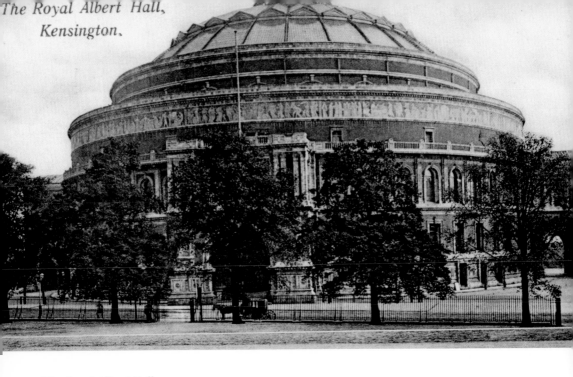

The Royal Albert Hall, Kensington.

The Royal Albert Hall

Opposite the Albert Memorial in Kensington Gardens, the Royal Albert Hall opened in 1871 as a part of the national memorial arranged by Queen Victoria to commemorate her late husband. It has been used to hold concerts by numerous star names and is now best known now for the Proms, held there in the summer.

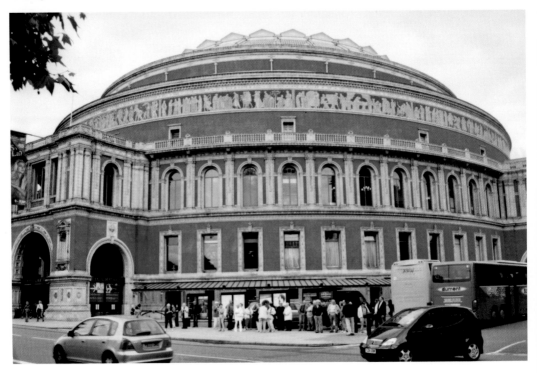

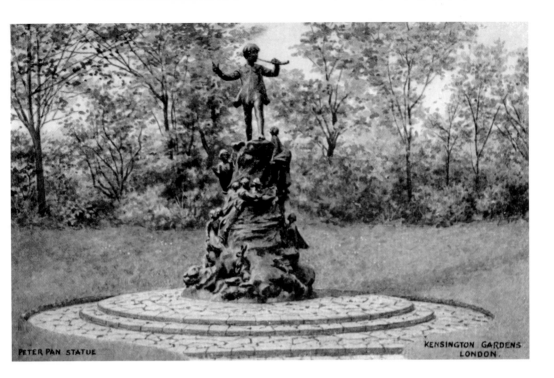

Peter Pan Statue

J. M. Barrie first met the Llewelyn Davis family in Kensington Gardens, and it was this meeting that inspired his most famous creation, Peter Pan. In his first appearance, in the novel *The Little White Bird*, Peter flies out of his nursery and lands on the spot by the Long Water where the statue stands today.

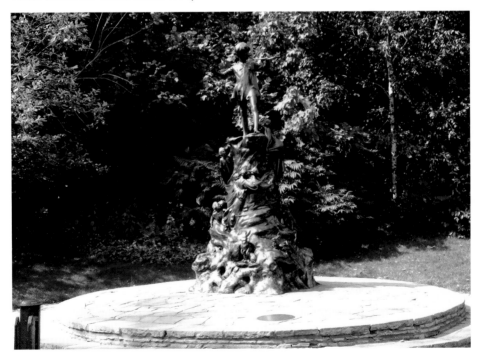

51

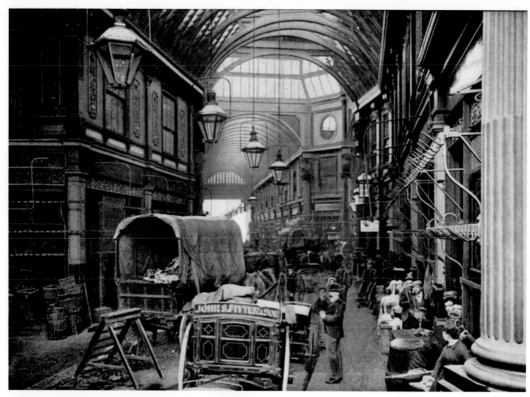

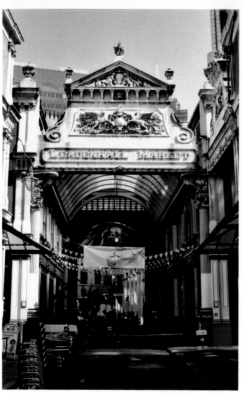

Leadenhall Market

The area around Leadenhall Market was once owned by the famous Richard Whittington, the subject of many pantomimes. It became a centre of commerce later and was well known for its leather. It was rebuilt in the late nineteenth century and made further showbusiness connections when it was used as Diagon Alley in the Harry Potter films. The market is now the site of a number of restaurants.

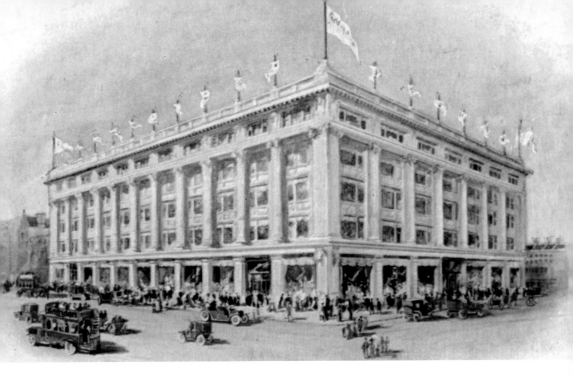

Selfridges, Oxford Street
This is the second-largest store in the country (Harrods is larger). It opened in 1909 and its displays have included Louis Bleriot's monoplane and the first public demonstration of television.

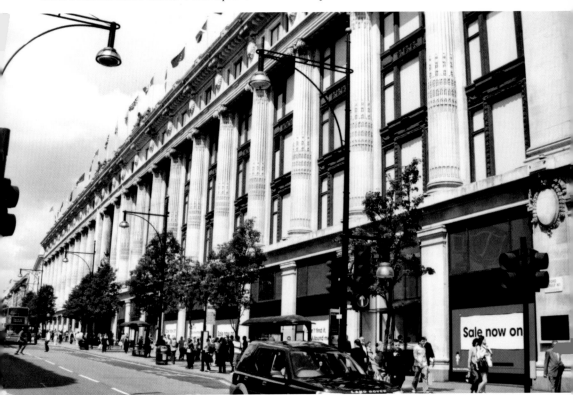

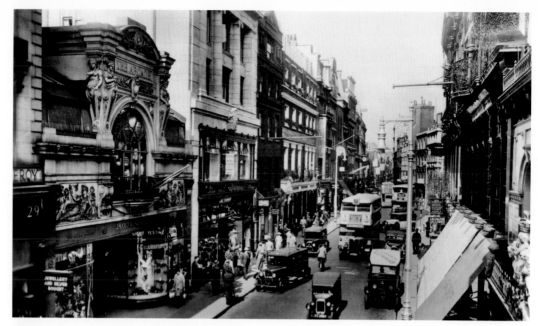

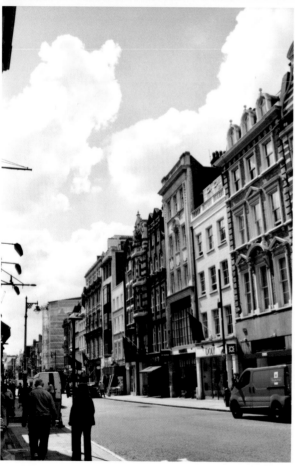

Bond Street

Bond Street is off Oxford Street and is part of the West End shopping district. Little has changed, besides the types of vehicles and the fashions.

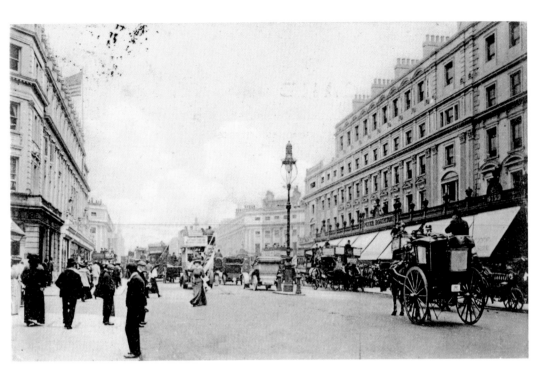

Oxford Street

Oxford Street has become the best-known shopping street in the country. The number of shops lining the street is not a recent development. It now has most of the well-known chain stores along its length. During a weekday, below, it is busy enough; the weekend brings even greater numbers.

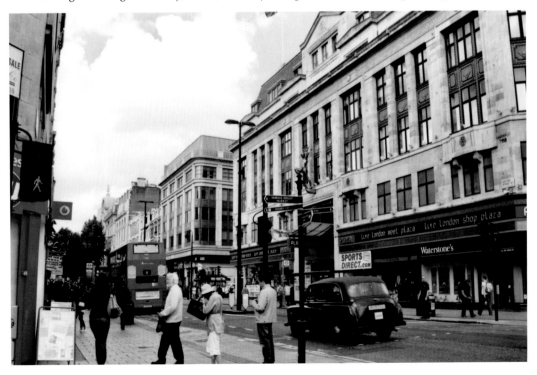

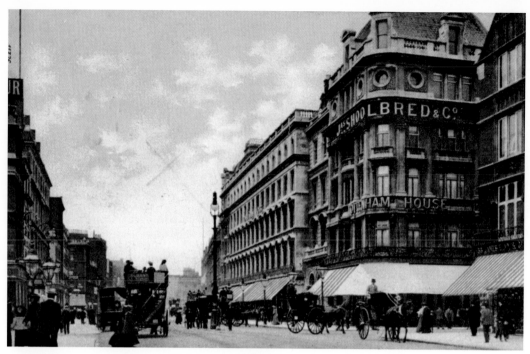

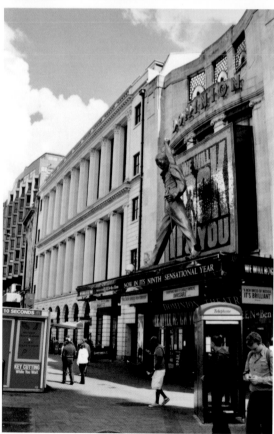

Tottenham Court Road

The street, also famous for shopping, was once known for the sale of electrical equipment, especially radio. It is close to Centre Point, a building that caused some controversy when it was built in the 1960s. On the corner with Oxford Street stands the Dominion Theatre, which hosts one of the longest-running shows of the moment, *We Will Rock You*.

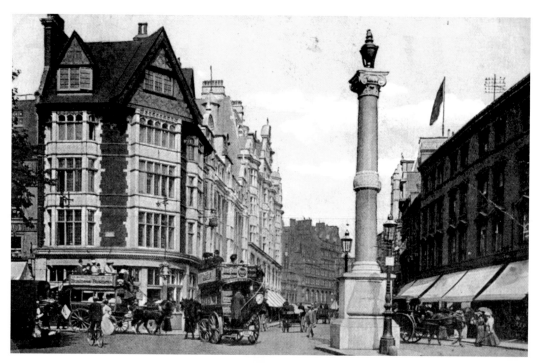

Kensington High Street

Another of London's many shopping areas, Kensington High Street was once known for the large stores of Derry & Toms, Barkers, and Pontings. It is now full of similar shops to other London shopping areas. Although these famous department stores have since closed, the fine buildings remain.

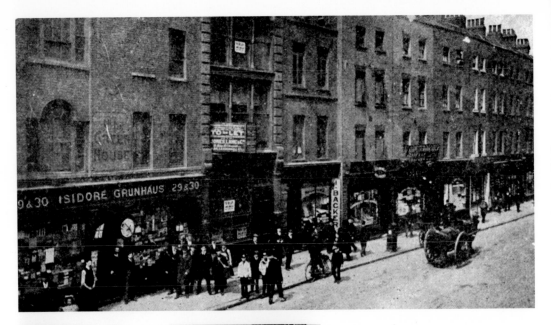

Houndsditch
This road is south-west of Spitalfields and Whitechapel, the area prowled by Jack the Ripper in the late 1880s. It was at one time dominated by the rag trade, but by the early twentieth century it was the place to go for novelty items. Although many of the old buildings survive, it has now become a more prosperous business area, dominated by newly created office space.

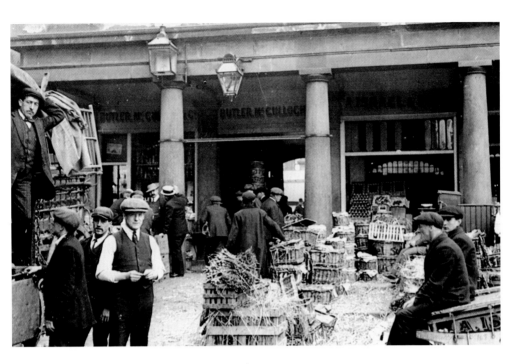

Covent Garden

A fruit and vegetable market from around 1654 until 1974 – when the operation was moved to Nine Elms – Covent Garden has now become one of the entertainment centres of London. Apart from the Theatre Royal Drury Lane, the Royal Opera House and the many restaurants in the vicinity, it is also famous for its unusual street performers. The London Transport Museum is nearby.

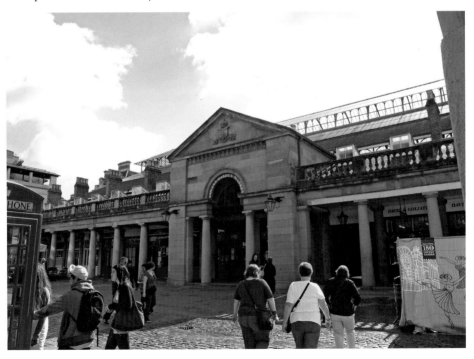

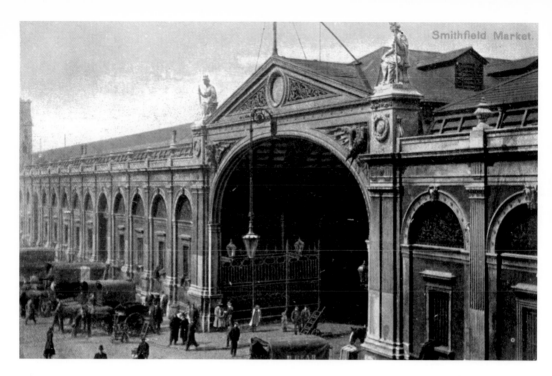

Smithfield Market

This has been the site of a meat market for hundreds of years, and it is now the only surviving wholesale market in Central London. It is also the spot where many well-known dissidents were executed, the most celebrated being William Wallace and Wat Tyler.

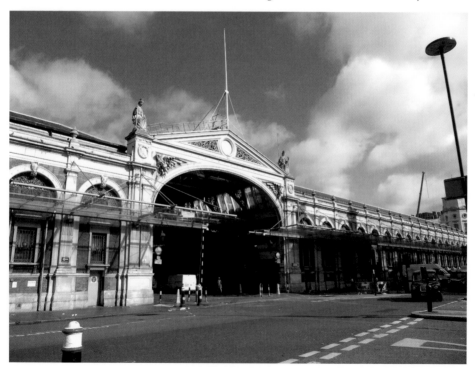

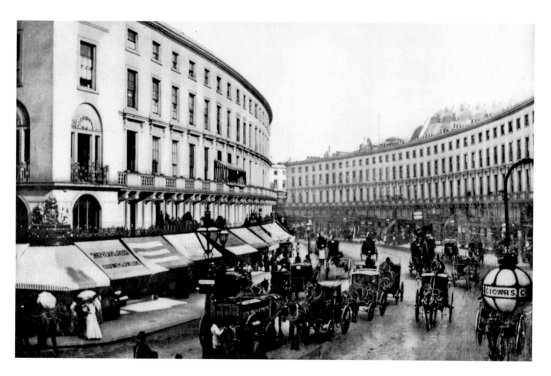

Regent Street

This West End shopping street was built in the early nineteenth century and was named after the Prince Regent, later George IV, to whose home it led. It is one of the best-known shopping streets in London and is famous for its Christmas lights. Above is the view looking towards Piccadilly Circus from the north-west; below is the approach from Waterloo Place to the south.

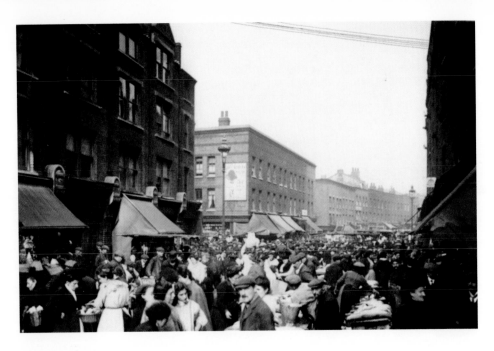

Petticoat Lane

There has been a market operating on the present site in East London since the mid-eighteenth century. It was known as Petticoat Lane because of the lace and underwear sold there. Victorian prudery dictated that there could not be a market named after woman's underwear, so the name was changed to Middlesex Street, but the clothing stalls are still referred to as 'Petticoat Lane Market'.

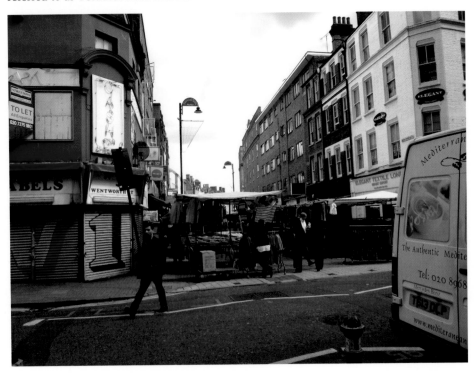

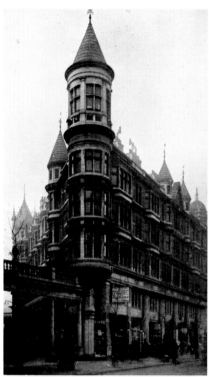

Sicilian Avenue
Built in 1910 as a pedestrians' shopping centre off
Southampton Row, Sicilian Avenue has numerous
restaurants. Despite its position in the heart of
London, it has maintained its Mediterranean flavour.

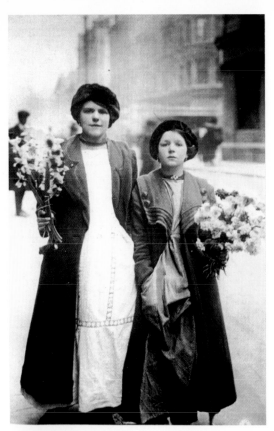

Street Sellers

In the nineteenth century, street sellers
such as flower and match girls were
a common sight on London's streets.
Flowers are still sold on the streets, but
they tend to be sold from stalls such as
this one outside Embankment station.

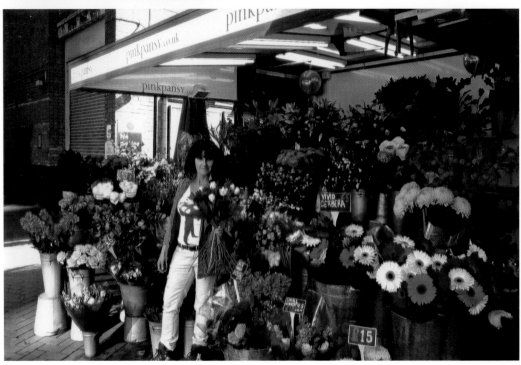

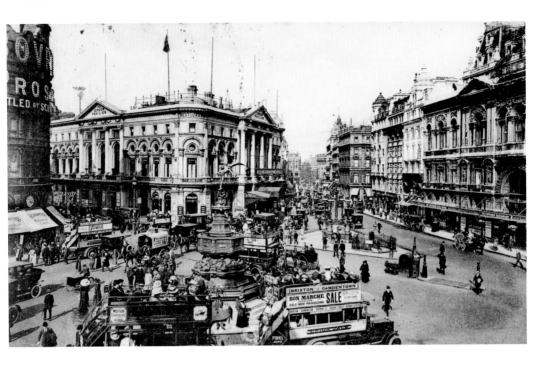

Piccadilly Circus

The area was built in 1819 to connect Regent Street and Piccadilly. The word 'circus' is used in the Latin sense to mean 'circle', i.e. a round open space at the junction of streets. The area is best known for its large neon signs and the statue of Eros.

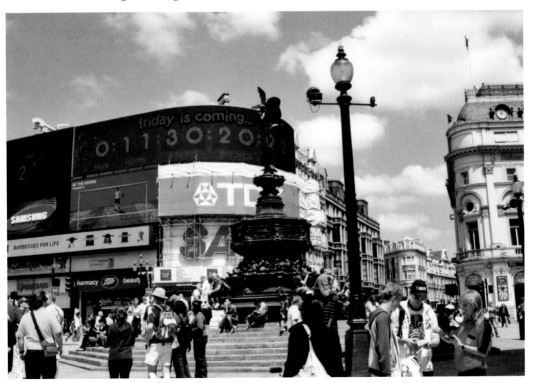

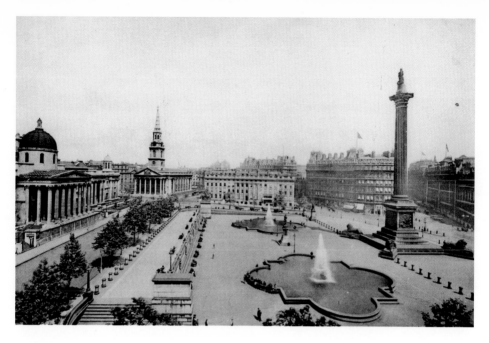

Trafalgar Square

Nelson, the victor of the Battle of Trafalgar – at which he died – is commemorated by Nelson's Column. The square was begun in the 1820s and was finally completed in 1845. The square has been the site of several demonstrations throughout its history and is a popular place to celebrate sporting successes and the New Year.

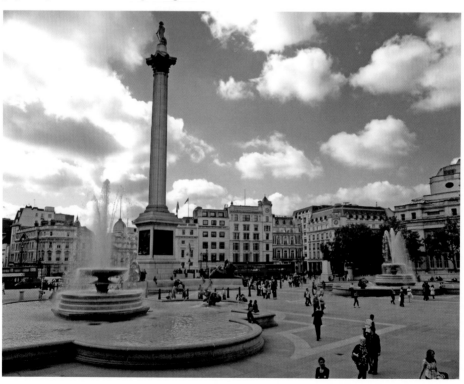

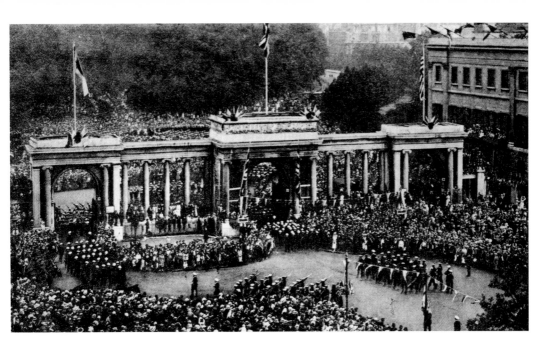

Hyde Park Corner

A number of main roads converge at Hyde Park Corner. The large central traffic island contains a number of memorials to various branches of the military. It was the scene of part of the victory march at the close of the First World War: you can see naval detachments passing Queen Elizabeth's Gate and the Hyde Park Corner Screen. In the same scene today, you can see to the right part of Apsley House, the former home of the Duke of Wellington.

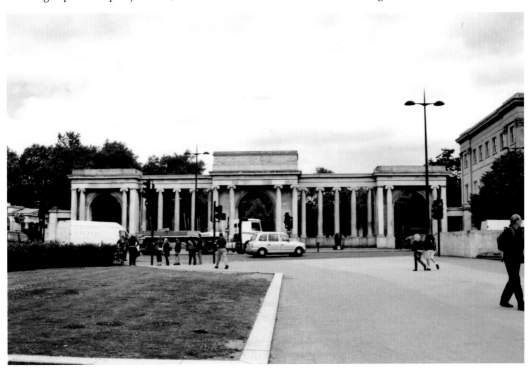

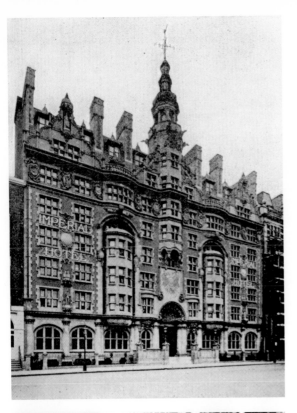

Russell Square
The Imperial Hotel in Russell Square has altered little, although the volume of traffic outside has increased. Trees have been planted across the road. It is now called the Russell Hotel.

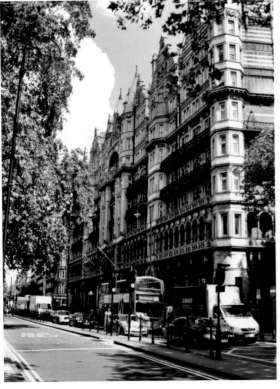

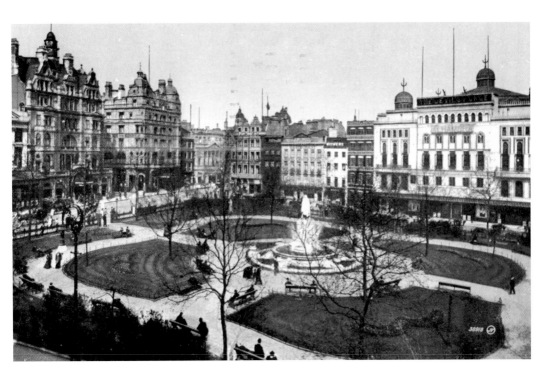

Leicester Square

The square gets its name from the Earl of Leicester, who bought the land in the mid-seventeenth century and built Leicester House. The king ordered him to allow part of his garden to be used by the public, hence the square. The area is now known for cinemas and theatres and is best known for film premieres at the Odeon.

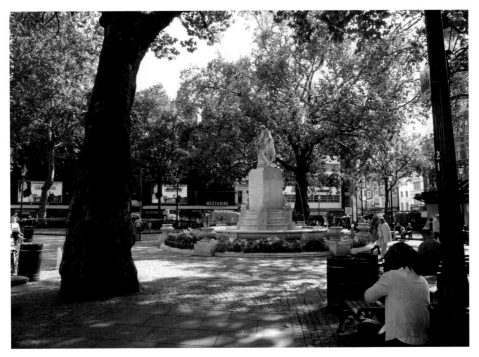

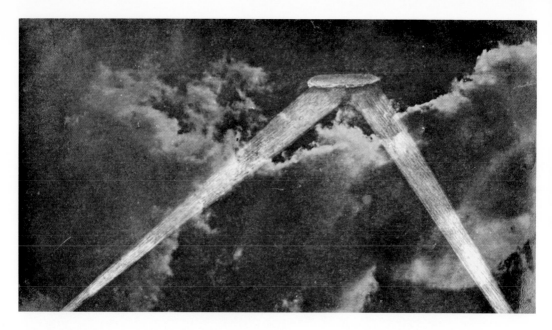

Queen Square

Zeppelins were much feared by Londoners during the First World War. It was the first time that civilians had faced air raids. The pleasant shade of Queen Square is a popular place with local workers and patients from nearby hospitals, including Great Ormond Street Children's Hospital. It is doubtful whether many of its visitors read the small plaque on the ground beneath the tree that marks the spot where one of the zeppelins' bombs fell.

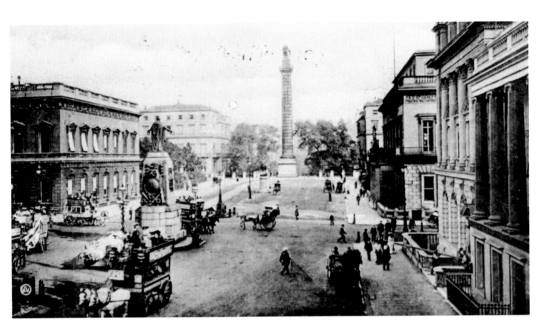

Waterloo Place

As well as many fine buildings, Waterloo Place, at the south end of Regent Street, is also the site of several statues. Many of these are of people who are no longer well known, however the area is dominated by a memorial to Prince Frederick, Duke of York and Albany (1763-1827), best remembered for marching his men up and down a hill in the children's nursery rhyme – possibly during the Flanders Campaign. The area is now dominated by parked cars.

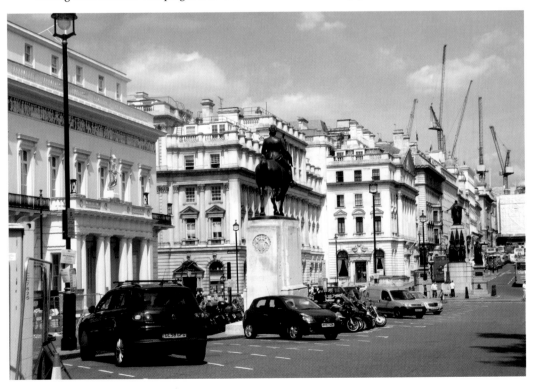

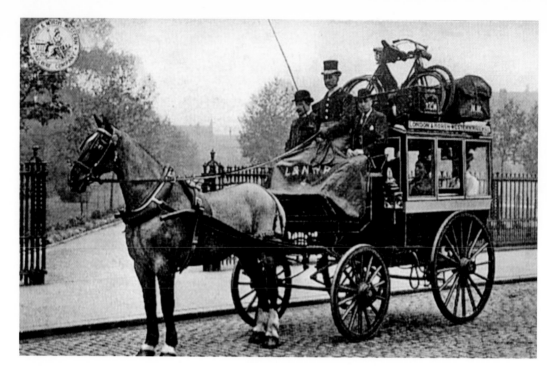

London Buses (I)

This is perhaps not something that people would associate with today's London buses. The single-horse family omnibus would however have been a common sight a century ago. A more recognisable form of transport in London, the 'bendy bus', has received some criticism.

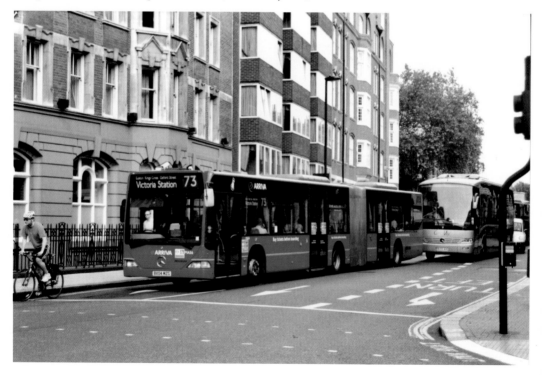

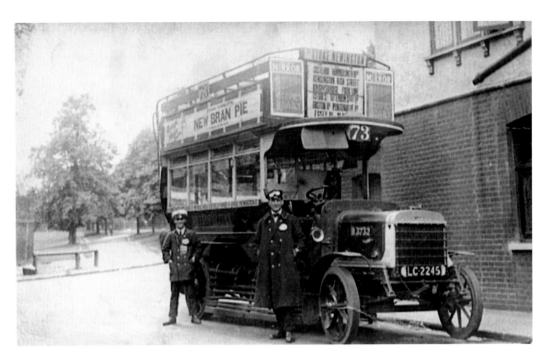

London Buses (II)

The open-topped bus seen in the old image would have been in use around the time of the First World War. How upstairs passengers coped with London's wet weather and the smog that enveloped the city does not bear thinking about. The open-topped buses today are just as familiar to the residents of London, although they are designed for the tourists.

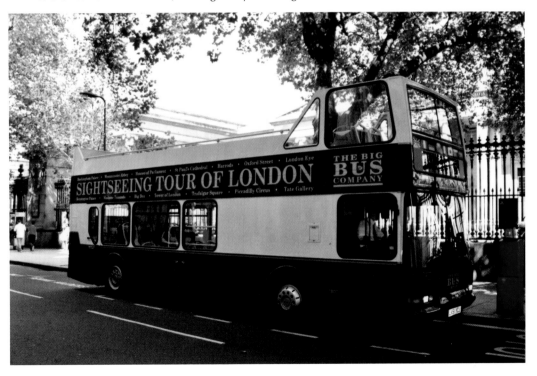

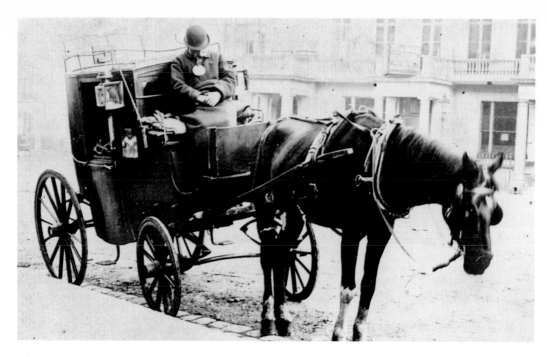

London Taxis (1)

The cabs of the past were based on horsepower, as this old image of a Hackney cab shows. The vehicles must be one of the best-known features of old London. The modern taxi is a bit more comfortable for the passenger, and no doubt the driver, too.

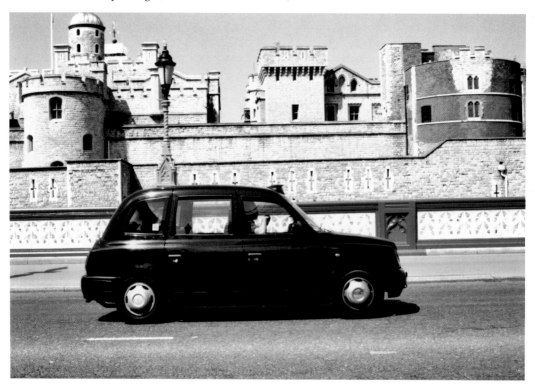

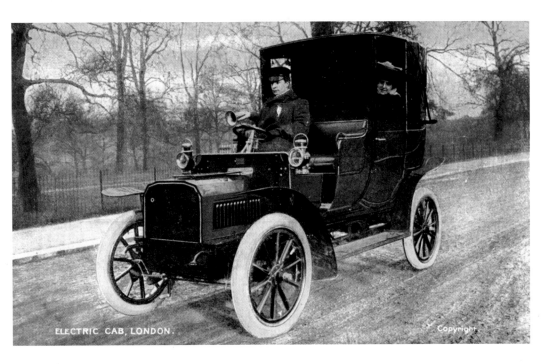

London Taxis (II)
What is unusual about the Edwardian taxi above is that it is an early version of something new to London's streets today, the electric car. Taxis today may still be black, as per tradition, but those of other colours are becoming more common. Many have advertisements all over them.

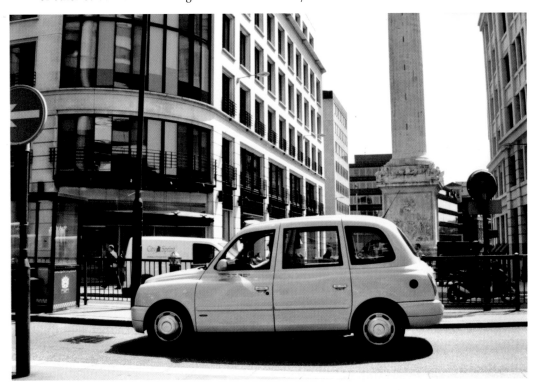

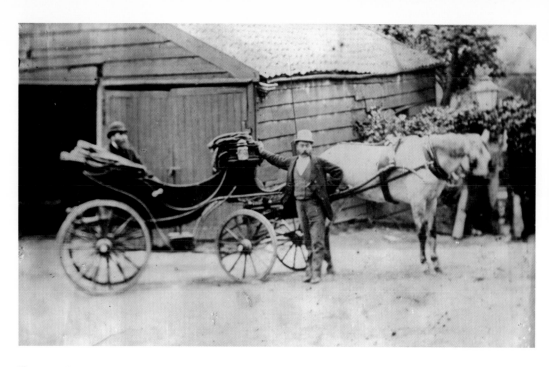

Transport

Coach and horse is the type of transport London's wealthy folk would have used at the end of the nineteenth century and into the twentieth. The transport of choice of the more affluent today is pictured below.

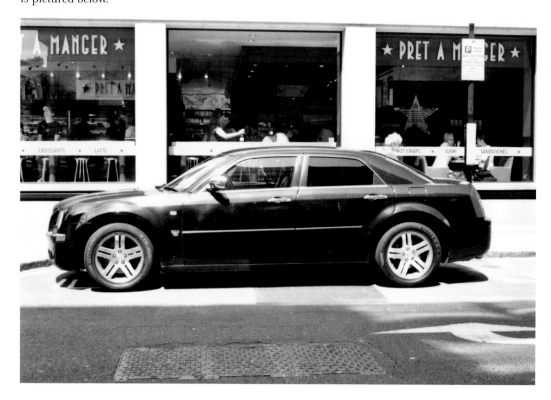

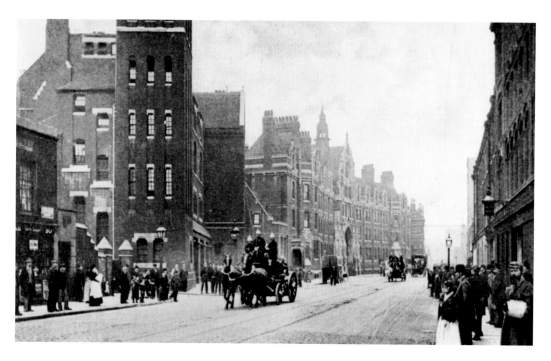

The London Fire Brigade

As with other public service vehicles on the streets on London, fire engines were once horse-drawn. The old fire engine would no doubt have looked very impressive flying through the streets with the firemen so visible. One of Shoreditch's present fire engines is here on display at a children's charity party at the Honourable Artillery Company's grounds.

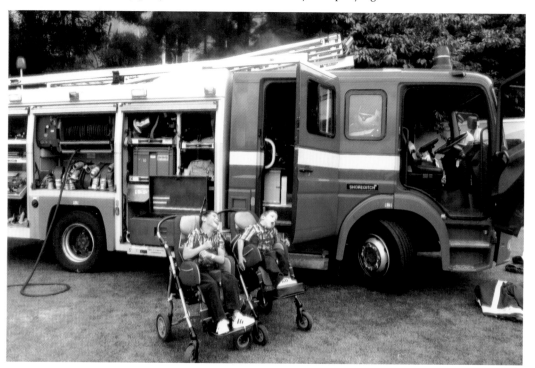

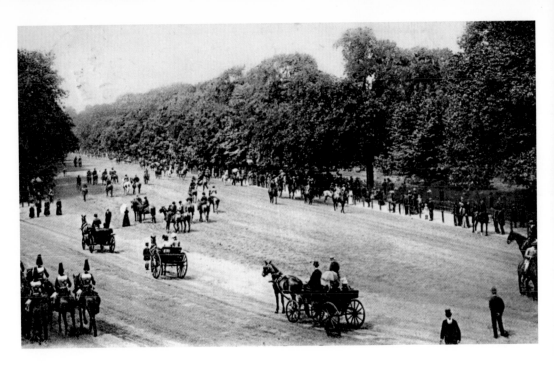

Rotten Row

This is a popular spot for carriages and those of an equestrian bent, as the old image shows. In the bottom left-hand corner there is a military presence. Rotten Row is still popular for riding, although bicycles are perhaps more popular than horses today.

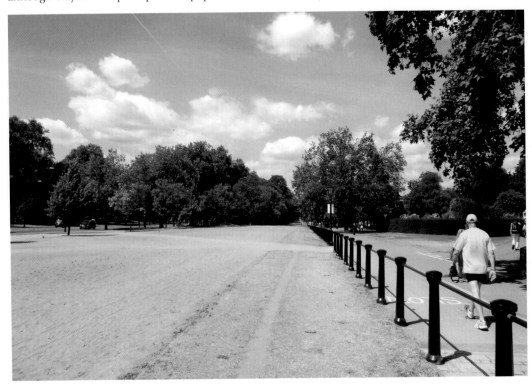

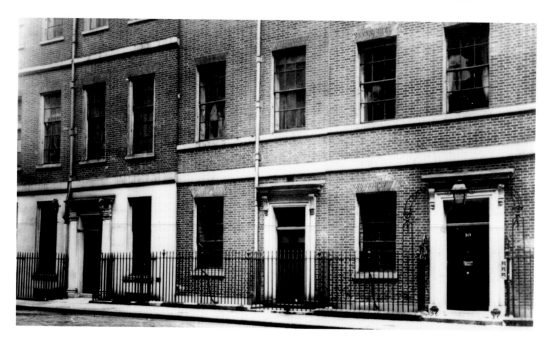

Downing Street

Dating back to the seventeenth century, Downing Street has for the past 200 years been the home of senior members of the British Government, including the Prime Minister. At various times gates have been erected across the street due to political unrest, for example in the 1920s during the Irish War of Independence. These were later removed. Gates were erected again in the 1982 due to further concern about terror attacks. The present gates were erected in 1989.

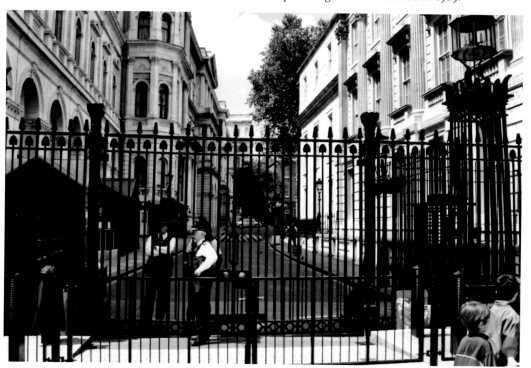

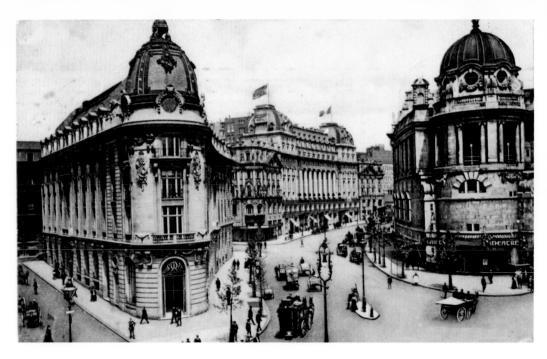

Aldwych

A crescent-shaped road that links Kingsway and the Strand, Aldwych includes a number of well-known buildings such as the Waldorf Hilton, the Aldwych Theatre and India House. This is another street in London that has since been lined with trees, disrupting the view of many of the buildings.

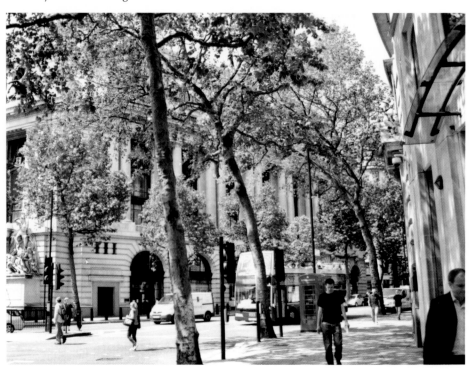

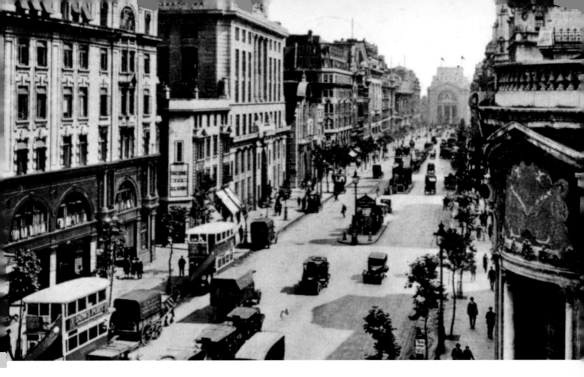

Kingsway

Stretching from Holborn Station to Aldwych, Kingsway was recently planted with a series of small trees. Today, the trees have grown to full height, obscuring the view of many of the buildings, as has happened in numerous other areas of the city.

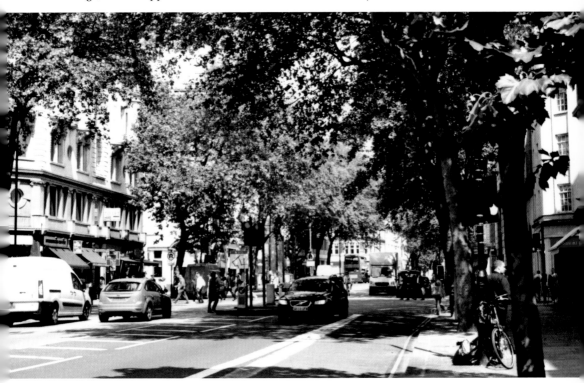

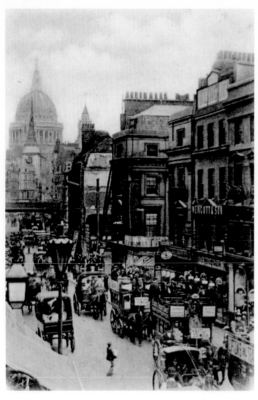

Fleet Street (I)

The street is named after the old Fleet River, which now flows underground. The street was the home of the British newspaper industry until the 1980s, when the newspapers moved out, many to Docklands. Fleet Street is still used as a metonym for the press. St Paul's Cathedral is clearly visible from the street.

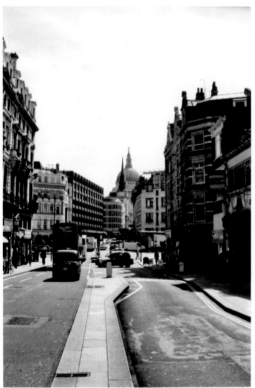

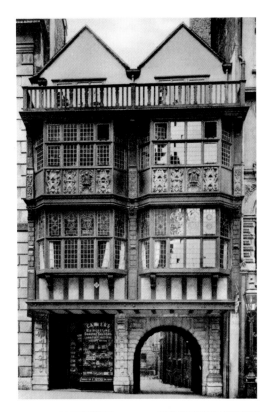

Fleet Street (II)

There are several very old houses standing in Fleet Street. Above is no. 17, although the numbering can be very confusing. Prince Henry's Room, below, is one of the few buildings in London that dates from before the Great Fire of 1666. It is now a museum. The archway leads to an alley that takes you to Temple Church.

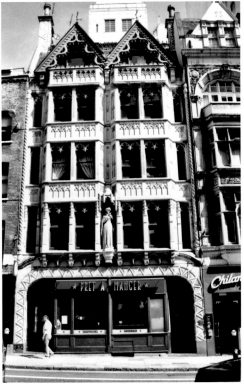

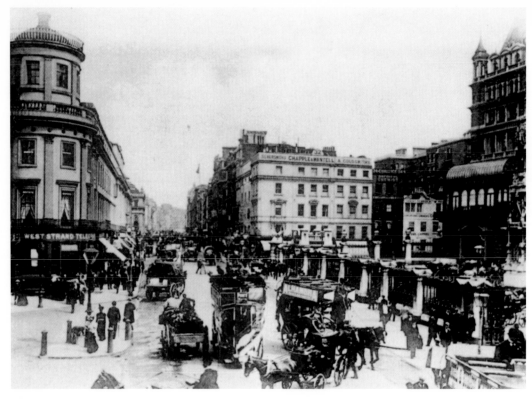

The Strand
The front of Charing Cross Station faces the Strand. The street is just under a mile long and stretches from Trafalgar Square to Fleet Street. Many of the buildings from the old image have been replaced with more modern ones.

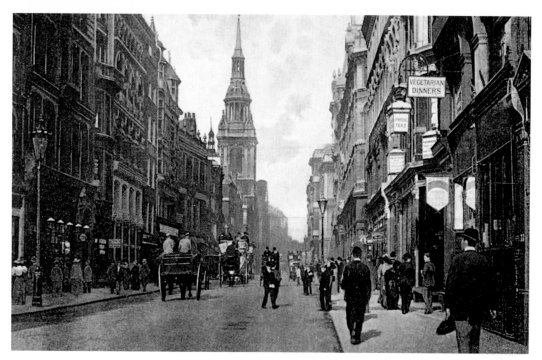

Cheapside

This was once the centre of London's markets. The types of goods sold in Cheapside are remembered in the names of the streets around it: Poultry, Milk Street, and Honey Lane. It is now just another street full of offices, as is the case with so many other London streets.

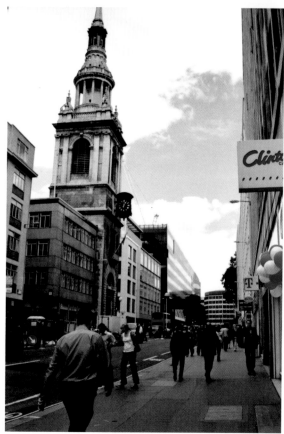

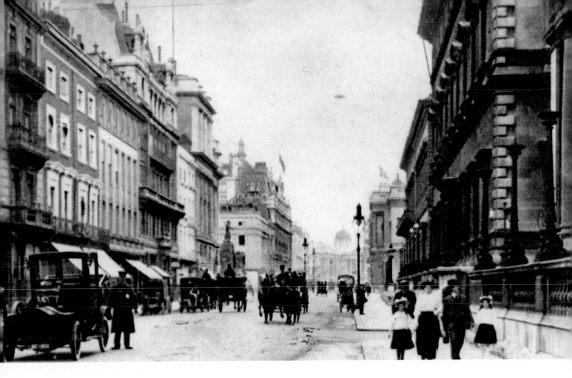

Pall Mall

The name comes from a game once played there, paille-maille, which involved hitting a ball with a mallet, as in croquet. It is also the name of a well-known brand of cigarette. The road, leading west from Trafalgar Square, used to be the site of some of the better-known gentlemen's clubs.

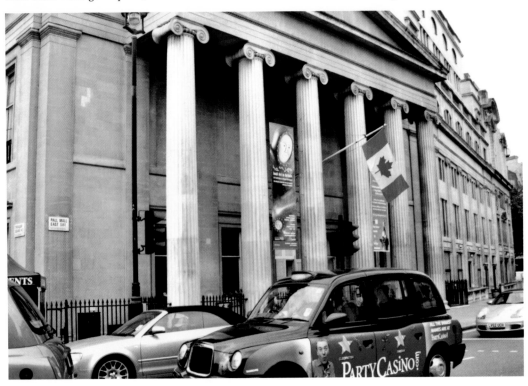

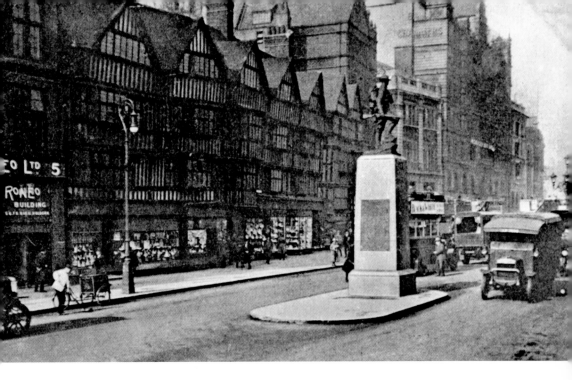

Holborn

The block of houses above is situated in Holborn opposite Gray's Inn Road. The memorial is to the Royal Fusiliers, who played their part in the First World War. Little has changed today, except for the kind of transport passing by and the types of business.

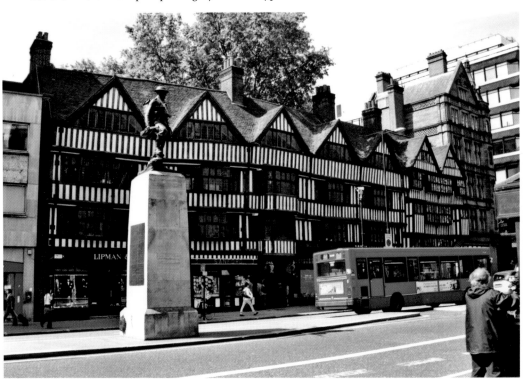

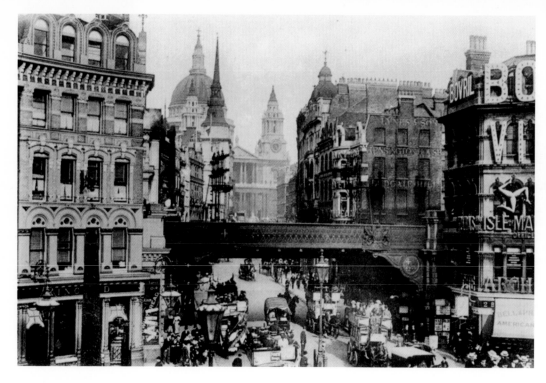

Ludgate

London's three hills are Tower Hill, Cornhill, and Ludgate Hill. St Paul's Cathedral stands on Ludgate Hill and is at the end of a street called Ludgate, which leads to Ludgate Circus. Many of the buildings have changed in the modern photograph, and the bridge across the street has now gone.

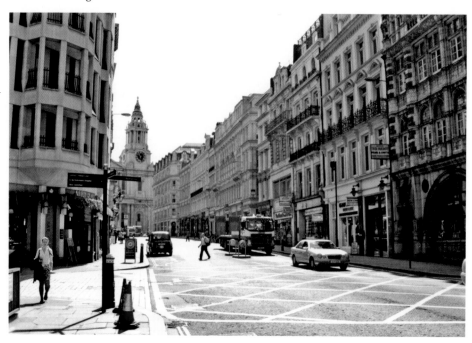

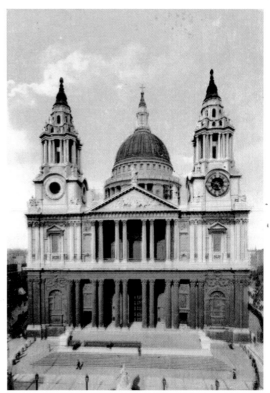

St Paul's Cathedral

There had been a cathedral on this site for centuries before the present building was designed by Christopher Wren after the Great Fire of 1666 destroyed Old St Paul's. Little has changed since it was built between 1677 and 1697.

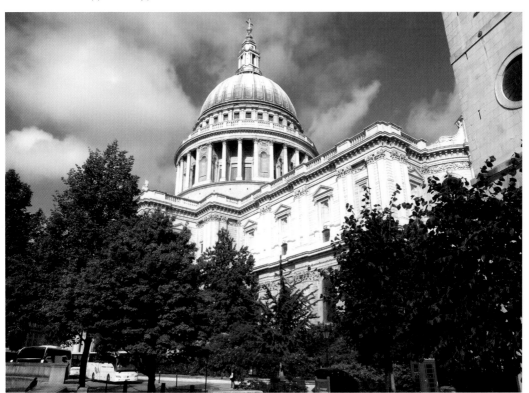

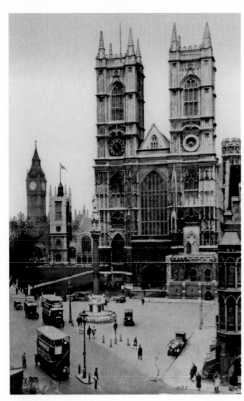

Westminster Abbey

British kings and queens throughout history have held their coronations in Westminster Abbey. William the Conqueror was crowned here after his success at the Battle of Hastings. It is also the burial site of a number of famous people, as well as the Unknown Soldier.

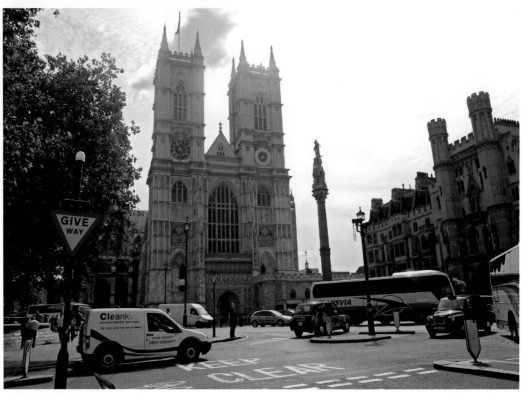

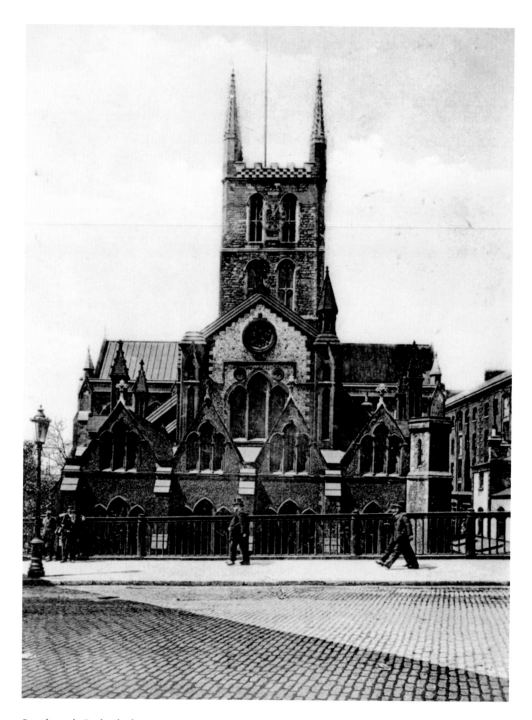

Southwark Cathedral

Although not as well known as St Paul's, Southwark is actually the oldest cathedral church in London, although it was only designated a cathedral in 1905. It stands on the south side of London Bridge, which is also the oldest bridge site of the city. The building is now surrounded by more modern buildings and railway lines. Local workers like to take a break from the outside hubbub in the churchyard.

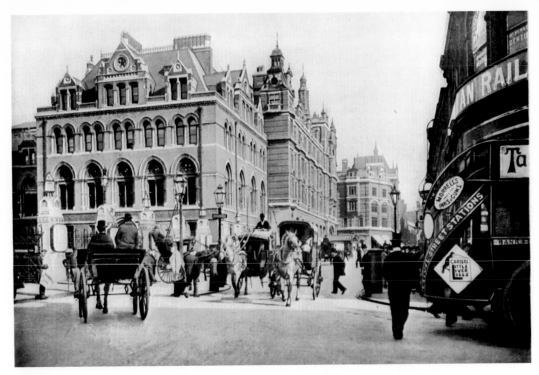

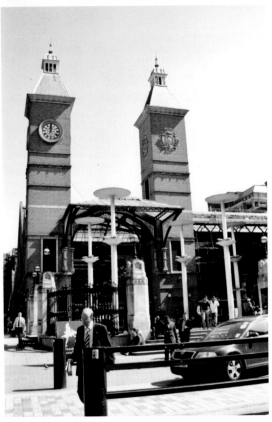

Liverpool Street Station

The station opened in 1874 and took its name from the street it was built on, which was itself named after Lord Liverpool, the Prime Minister from 1812 to 1827. In the First World War, 162 people died in the station when it was hit by an enemy bomb. During the 1930s, a number of Jewish children evacuated from Europe arrived here. A memorial to them has been built just to the right of the modern view.

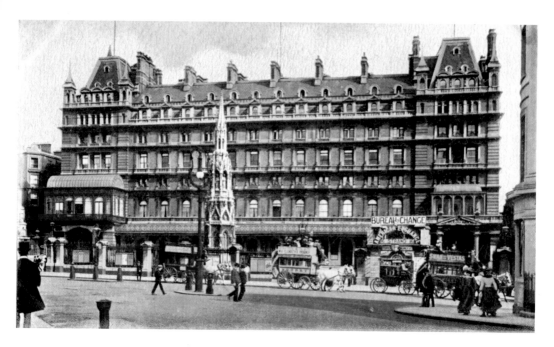

Charing Cross Station

The station opened in 1864; the hotel above it the following year. Outside the station stands the Eleanor Cross, a copy of the Whitehall Cross, which was demolished in 1647. Unfortunately, the cross was covered in scaffolding when I visited.

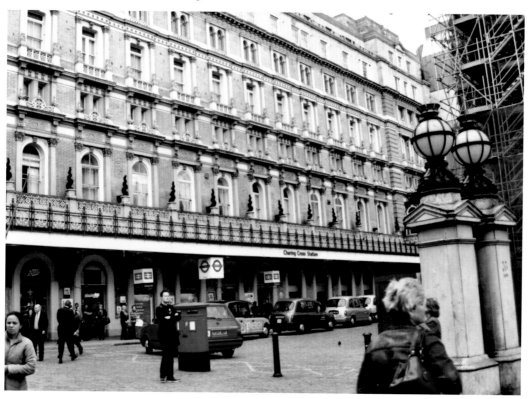

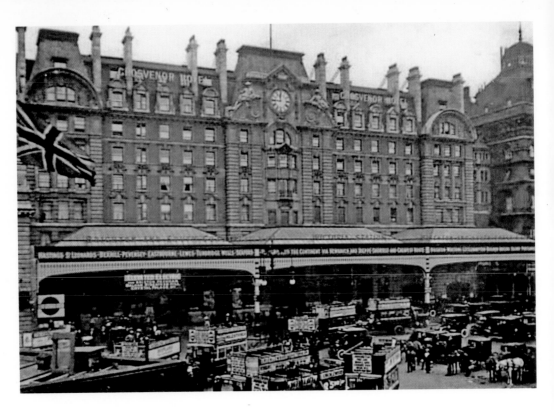

Victoria Mainline Station

The station was built to provide a rail service between the south of England and the north side of the Thames, especially Westminster. It opened in 1860 and was divided into two parts, each run by a different rail company.

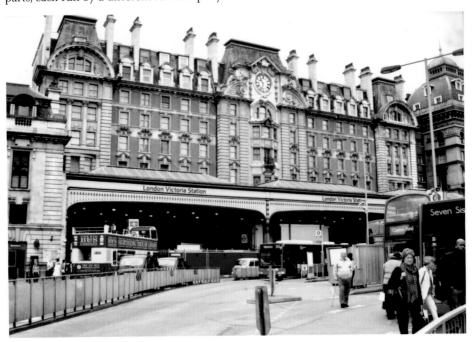

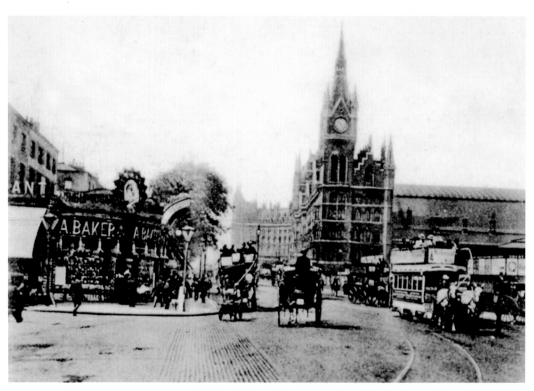

St Pancras Station

The station was built in 1868 with the largest single-span roof in the world. There were failed attempts to close and demolish the station in the 1960s. It was rebuilt a few years ago and in 2007 became St Pancras International. Although the outside of the building has changed little, inside it is now the modern terminus for the Eurostar service to Paris and Brussels.

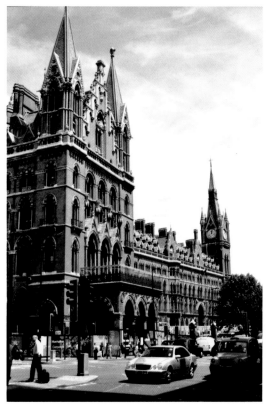

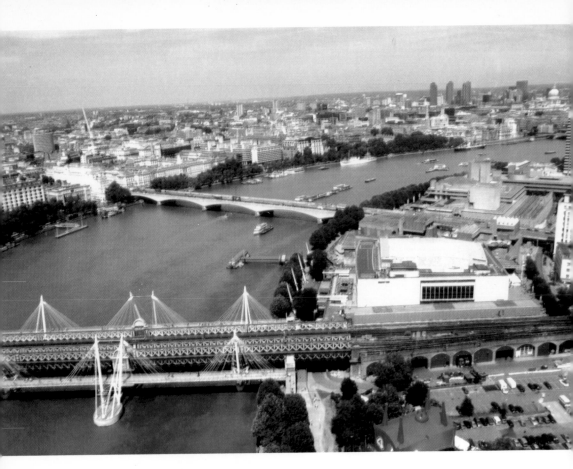

A view of the River Thames from the top of the London Eye. This view of the city was not available to Londoners prior to 1999.

Acknowledgements

Thank you to Joanne and Elle Tansley and Lisa Bloomfield for their help in taking the photographs in this book.

Find out more about Michael Foley's books at *www.authorsites.co.uk/michaelfoley*.